mantra art

mantra art

THE JOURNEY WITHIN

Juss Kaur

KASHI HOUSE

LONDON

First published in Great Britain in 2019 by

KASHI HOUSE CIC
27 Old Gloucester Street, London, WC1N 3AX
www.kashihouse.com

A CIP catalogue record for this book is available from the British Library

ISBN: 978 1 911271 13 0

Publisher: Parmjit Singh
Senior Editor: Dr Bikram Brar
Layout, typesetting & reprographics: Tia Džamonja
Prepress: Miho Karolyi

Printed by Liberdúplex, Barcelona

Front cover image: The Blue Lotus by Juss Kaur (page 98)
Back cover image: Autumn Leaves by Juss Kaur (page 6)

For my beloved
with deepest love,
reverence
and gratitude

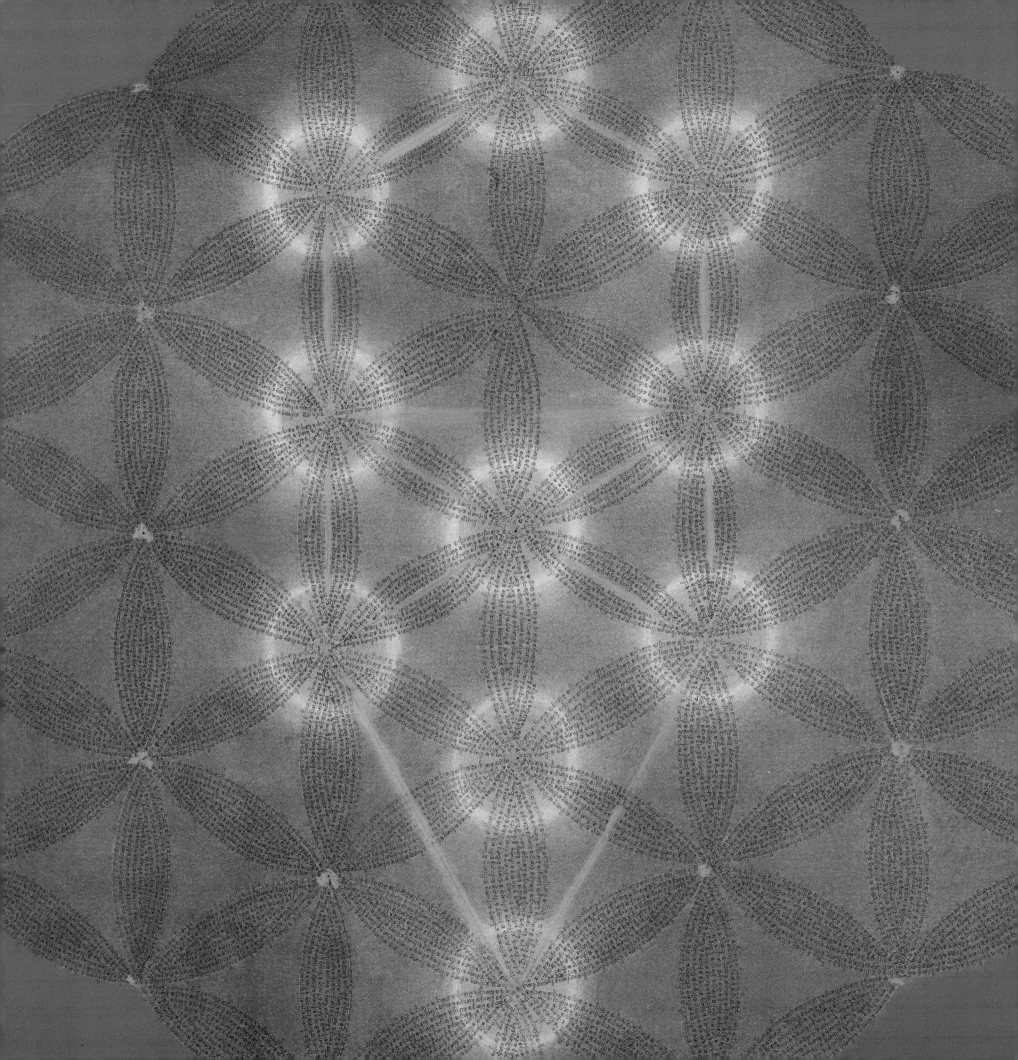

CONTENTS

INTRODUCTION

ਵਾਹਿਗੁਰੂ

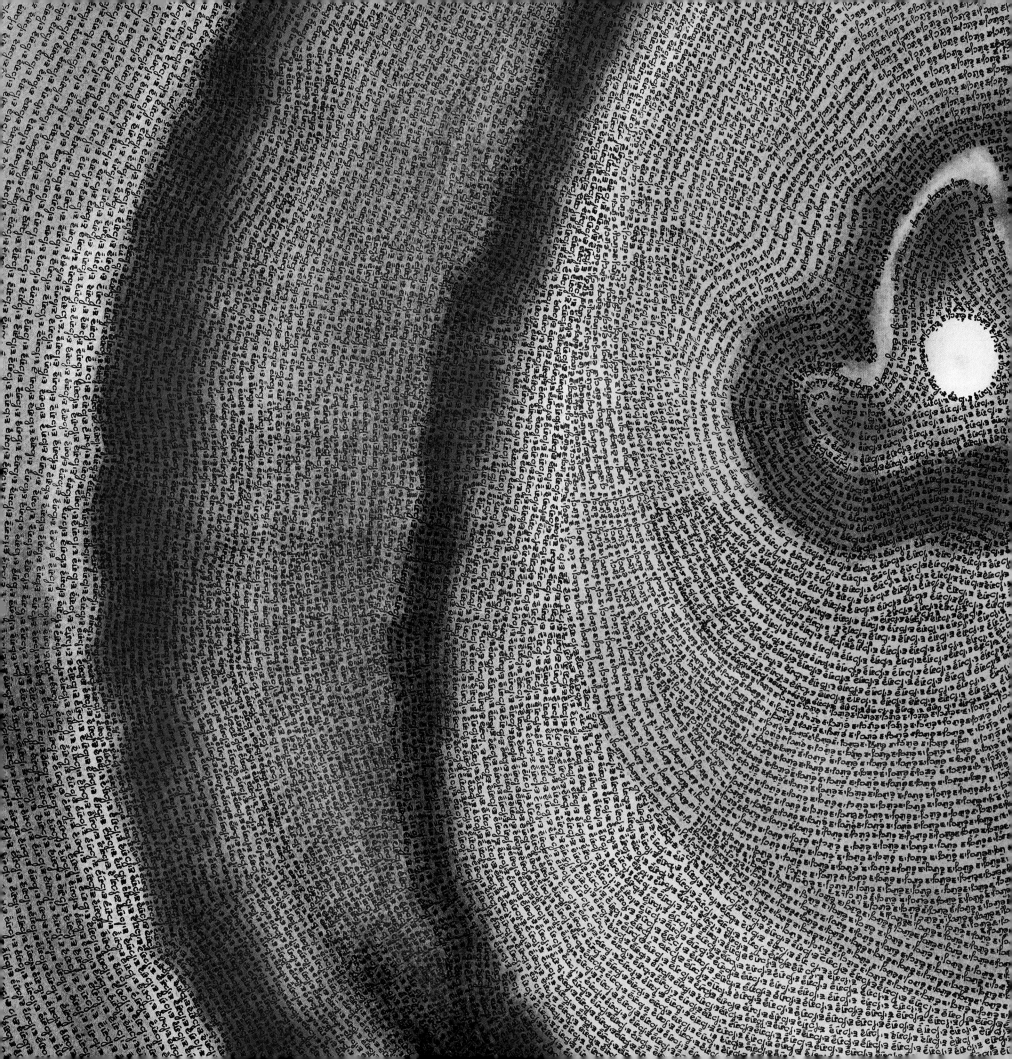

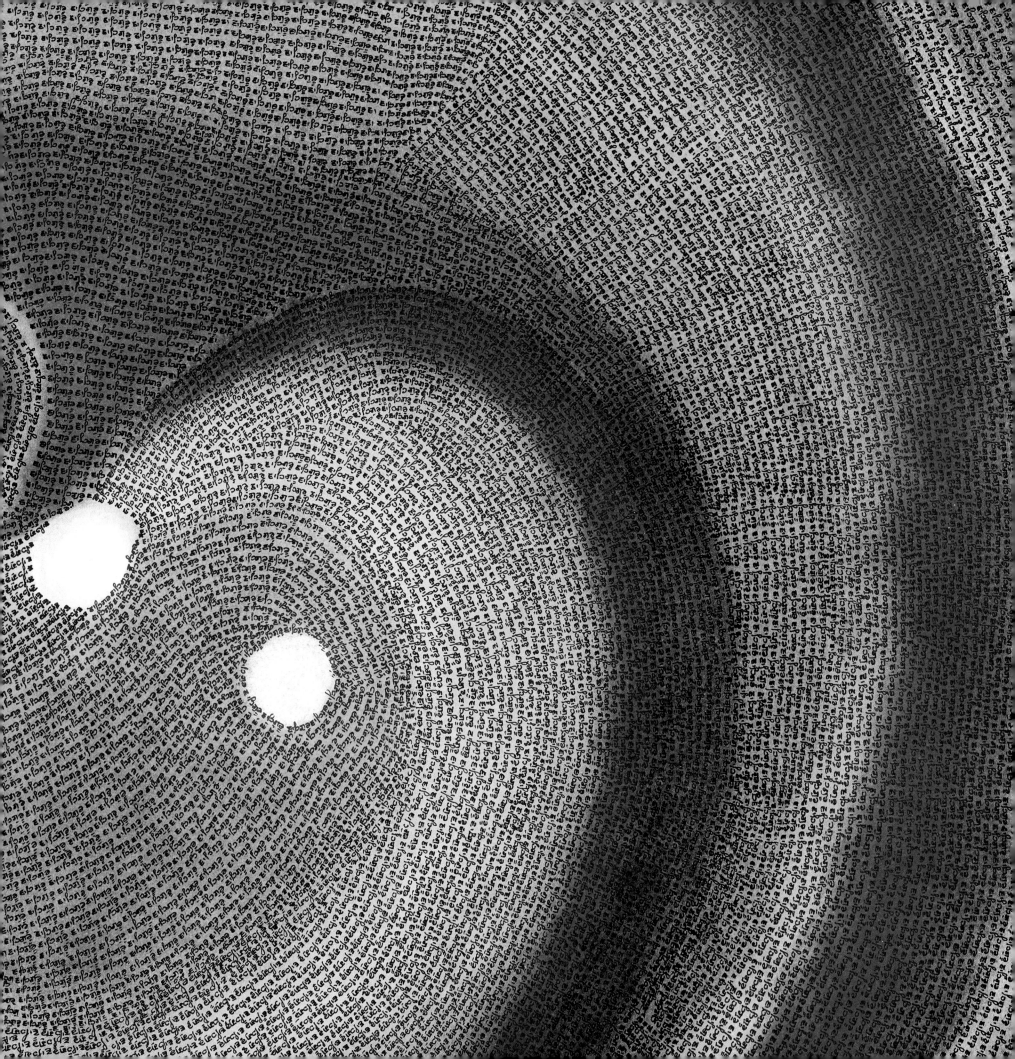

What is Mantra Art?

*Art enables us to find ourselves and lose ourselves
at the same time.*

– Thomas Merton

In 2005, the National Science Foundation published an article regarding research about human thoughts. Amazingly, the average person has 60,000 thoughts per day and 95% of them are exactly the same – day in, day out! When a person manages to become completely immersed in a creative endeavour, they may find themselves in what is known as 'the zone', a state of 'flow' or 'absorption' that completely focuses the mind and temporarily pushes aside all irrelevant thoughts. Art acts as a form of meditation when one begins to concentrate on details while paying more and more attention to the present environment. In the process of creating, we learn to quieten ourselves, to listen and to let creativity flow though us. Just like any other type of meditation, focusing our concentration on one thing helps us in breaking free from the constant debilitating chatter of our thoughts, allowing us to discover our inner space and connect to the harmony and beauty of the universe.

Meditative art, or mantra art as I call it, is not a modern concept; it has traditionally been a natural and integral part of spiritual paths worldwide. Some well-known examples of meditative art from the East are Chinese calligraphy, Indian mandalas and yantras, Tibetan sculpturing and drawing, Zen poetry and the Sufis' whirling dance. Buddhists have a practice of creating intricate sand mandalas – circular designs with concentric shapes – that are intentionally swept or washed away upon completion. These creations are a meditation on life's impermanence.

To understand mantra art, one must first ask the question: what is a *mantra*?

This Sanskrit word is derived from two roots: *man* meaning 'mind' or 'to think', and *tra* meaning to 'protect', to 'free from', or 'instrument'. A mantra is a tool of the mind used to free itself. Sound, rhythm and speech have profound effects on our body, thoughts and emotions. Mantra meditation uses the vibrations emanating from these three elements. By harnessing their power, we can purify, pacify and transform both our mind and heart by aligning them with the vibrations in the cells of our body.

Every 'thing' in the universe vibrates, and each has its own rhythm. Our thoughts and feelings are vibrations in our body and our consciousness. The mantra is like a password, a key, to attain a certain state of consciousness.

In effect, they are sounds that, through constant repetition, produce vibrations that penetrate the depths of the unconscious mind. Whether this be done through chanting aloud, mental practice, or even by simply listening to them, mantras adjust the vibration of all aspects of our being. During this process, the Super Consciousness or Divine Self is said to become activated, allowing us to experience a sense of the Infinite.

Breath is a divine gift, and when we use it to utter sounds, those sounds also carry the creative power of the universe within them. Words have power, and by becoming conscious of what we say all the time, we are capable of experiencing that creative power, because the words we choose plant vibratory seeds that, sooner or later, sprout – for better or for worse.

For me, creating art is a form of meditation and spiritual dialogue. My personal pathway to art truly opened while I was a teacher making sketch drawings to pass the time while my students wrote exams. Yet as a young student myself, I was captivated by science, which informed my own artistic spirit. I loved to question, explore and employ it as a muse to inspire wonder, and to capture the complexities and mysteries of the invisible.

Thus, mantra art can serve as a tool to bring one to the present moment. It is a way of driving inwards to the source of creativity, allowing us to get in touch with, and to expand, our true inner selves.

Each painting takes me on a journey and, as my paintbrush and pen follow, each time I am led back to my centre. It is in the process of creation that I find my rhythm – all stands still as my inner teacher takes over. As I witness the evolving process, I am left in awe. I feel a deep awakening, a potent blossoming of the creative energy that is all around us – not only in our own lives, but also in those of our family and community, and in the collective experience.

As in any art form, we release judgment, silence our mind, breathe deep into the process to find bliss in each step. Realising that we are boundlessly assisted in our authentic and heart-centred expression, we step out of the way. Art is not born *of* us but *through* us and, with this understanding, we are humbled yet profoundly empowered. Over time, I have come to recognise that it is our divine duty to create and share inspiration. As we honour our own personal creativity, we contribute vitally to the whole. We inspire those around us to celebrate and we empower them to create. My purpose now is entirely clear: to create reflective works of art that engage the soul, both yours and mine, to celebrate and share the joy of this glorious adventure, to inspire and be inspired.

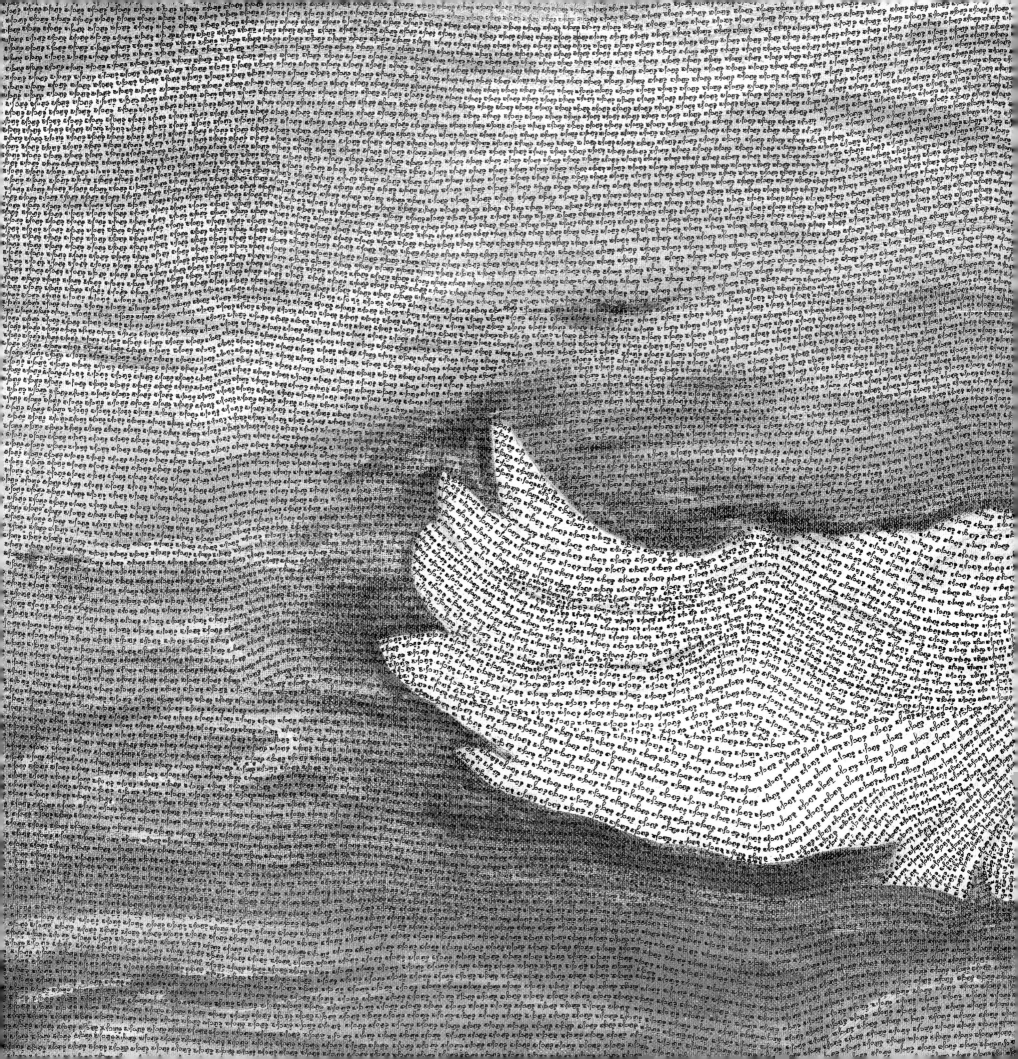

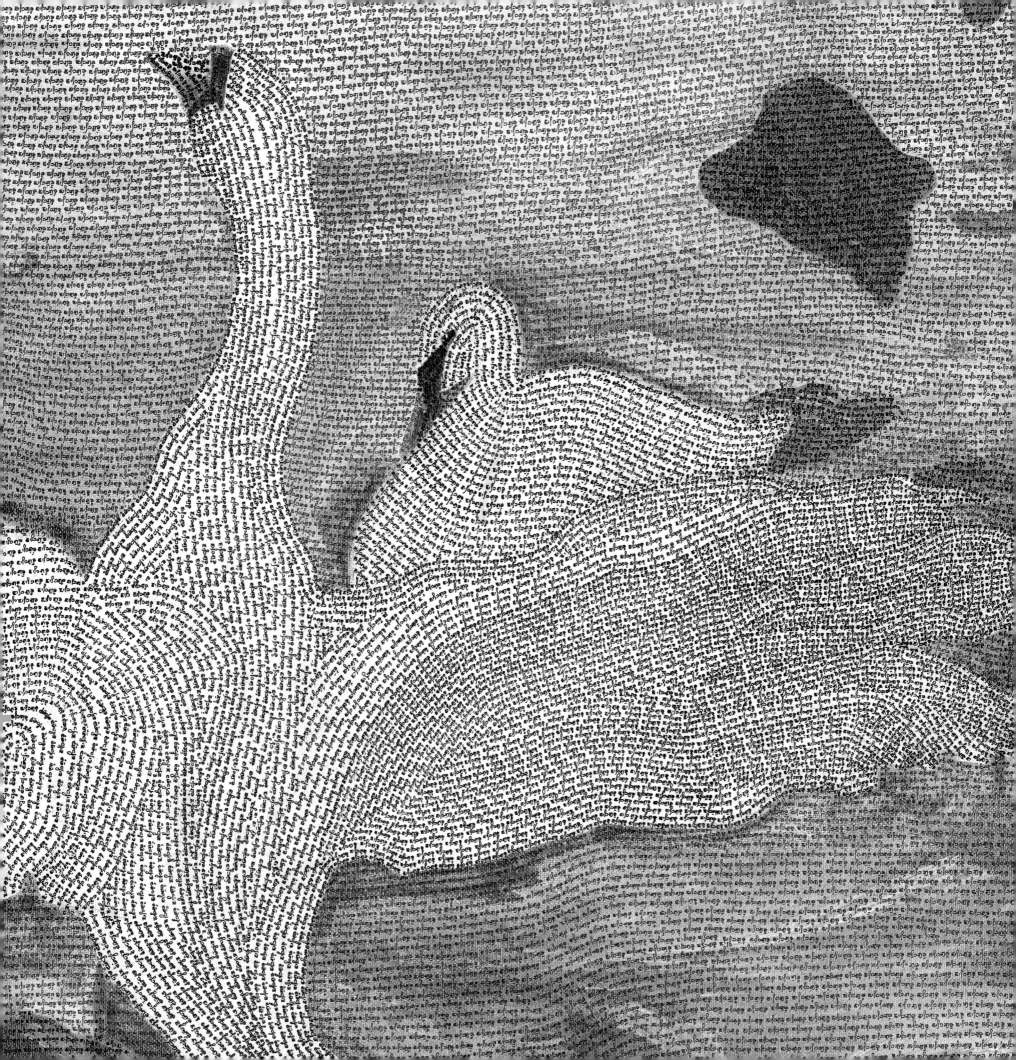

The Journey Begins...

In your light I learn how to love,
In your beauty, how to make poems
You dance inside my chest where no one sees you,
but sometimes I do, and that sight becomes this art.

– Rumi

Before telling my story, I want to express a debt of gratitude for the spiritual metamorphosis that my beloved spiritual guides instigated in my life. My journey has been shaped through their spiritual integrity and I am blessed to feel their continued presence in my life.

Fear and self-doubt can often have disabling effects, preventing us from achieving anything. However, without fear a whole new world opens up – one in which anything is possible. I learnt this when I was a seventeen-year-old student working to earn my tuition fees.

My brother was getting married and I wanted to give him a very special gift, one that both he and my sister-in-law would cherish. I have no idea what prompted the thought of creating a painting. I had never picked up a brush, knew nothing about canvas and oil paint, but here I was painting Sohni Mahiwal – the tragic Punjabi tale of true lovers, much in the same vein as Romeo and Juliet. Without much thought, I copied the image of a painting by Sobha Singh onto a canvas and started to paint. The fearful idea that it may not be something that they would like never even entered my mind; I was driven only by love. Inspiration came from within – I simply listened and followed.

Fortunately, it ended well! Fifty years later they still have it.

Even now, when I recall this accomplishment, I am filled with awe. This was truly the beginning of my journey within.

Discovering Inner Life

Painting embraces all the ten functions of the eye;
that is to say,
Darkness, Light, Body, Colour, Shape,
Location, Distance, Closeness, Motion and Rest.

– Leonardo Da Vinci

Several years went by following that first foray into painting. During this time, I married and had three children. When I finally decided to paint again it was to decorate the walls of our new home. One painting was of a half-naked woman in deep contemplation while sitting under a tree holding a bird. For some reason, everything was in red. The second painting was of two swans in a body of water, with one of them in flight. I have no recollection of why and what made me choose these particular images, but something had drawn me to them at the time. I have now come to learn that everything that happens in the creative process – every choice, every touch of paint, every emotional feeling – is an important ingredient in the final offering. When you realise that, there is no room for fear.

Several years passed before I attempted to paint again. During that time, a number of things happened that dramatically changed my outlook on life.

I have been on a so-called 'spiritual path' for many years, guided with a bit of serendipity and inspiration by many glorious masters. I had the good fortune of having them appear either in person or through their presence in enduring, timeless words of wisdom in various books. Under their aegis and patronage, through every baby step taken and through each fall, I have felt lovingly lifted by their ushering hand. Over time, I came to learn that we are all our own teachers but, occasionally, we need external assistance – a guide to help point us in the right direction when we get lost.

Along the path, we invariably meet several fellow travellers who in turn become precious guiding lights, but they too only remain for some time. One or two of these loving kindred spirits become particularly close, forming deep impressions on your life. They come to serve a purpose, and when it has been served, they too depart. However, they remain in your soul forever, ever fresh, each one bringing you closer to your own self-realisation.

Another truth that has gradually become clearer to me is that regardless of how spiritual one may feel due to following religious dogmas, rituals or attending congregations, unless action is taken to truly internalise and live what is learnt

from the golden messages, all is rendered useless. This internalisation can be only achieved through constant silent introspection, meditation and contemplation of the divine virtues: omnipresence, omniscience, omnipotence. By learning to be still and becoming aware that we are not finite human beings but pure Consciousness, we move beyond words and thoughts. This awareness of being One is the ultimate prayer in itself. Sitting at the feet of the master inside our own consciousness, in the deep well of silence, the still, small voice reveals the nature of our being, helps us to seek answers to deeper questions, including who we are, what we are and why we are here. All masters, being eternally united in the Consciousness, urge us to reclaim our own divine heritage.

I have been extremely fortunate to have had the freedom to explore various spiritual paths, mostly through my readings. I was drawn to my first guide, or master, in my early thirties. Until then, my life had revolved around education, work and the five Fs: family, food, fashion, friends and fun.

I was very content and happy in this life of extrinsically sought-out joys, even with its rollercoaster effects of rewards and disappointments. The only 'holy' thing we did was to go to the *gurdwara* (Sikh place of worship) every Sunday, but that too was timed beautifully to be towards the end of the service, just in time for us to parade our beautiful clothes and eat. I had no idea about the treasures, the gems that lay dormant within me – happiness, peace and contentment of a different nature.

On those weekly trips, I prostrated mindlessly in front of the sacred Sikh scripture, the Guru Granth Sahib, completely oblivious to the loving messages embodied within the text, written by masters of various paths and times. They were calling me to recognise this inner kingdom of love and joy, to become mindful of an intrinsic life of freedom. The Guru Granth Sahib was a closed book for me; to study and search for spiritual meaning was not on my agenda. In fact, after every temple visit, we would proceed to go watch a movie, which tended to reinforce a more extrinsic life of what it means to be rich, beautiful and happy. This continued well into my thirties, until, on the insistence of one of my relatives (who was cognisant of what it means to meet an enlightened soul), I was introduced to my future spiritual guide, my teacher, my beloved master whom I will simply refer to as 'B'.

B's message of Universal Religion, Divine Love and Divine Will was new to me. The preachers at the temple may have talked about it, but I was never there on time for their discourses. Now, when I heard B talk about inner intuitional experiences of the soul and the Divine Realm, I was drawn magnetically not only towards this loving messenger of God, but to the messages too. I wanted to know more about what he meant by a Universal Religion and what Divine Love was, so I started attending more and more discourses and retreats. B urged and encouraged everyone to recognise their own divinity and to become an embodiment of Divine Love. Because he was

talking from his own intuitive experiences, everything B said had immediate effects on those who were listening seriously. We were all infected with love.

I was further amazed to learn about the *Power of Thoughts* (one of the many booklets written by B as a key to understanding the intrinsic message of the Sikh scriptures), about the positive versus the negative and how they affect our present and future. B emphasised that although the only power is the One, thoughts were significant as they could lead you to experience It. I learnt about the intricacies of meditation and the necessity to go within one's self to practice daily introspection to address any lingering hate, jealousy or anger being harboured against anyone. I discovered the subtle nature of ego and its ubiquity in every source of discontentment, sorrow and even happiness. It also became rapidly evident that the ego was a very cunning warrior with ever-changing strategies of waging war at all times and places.

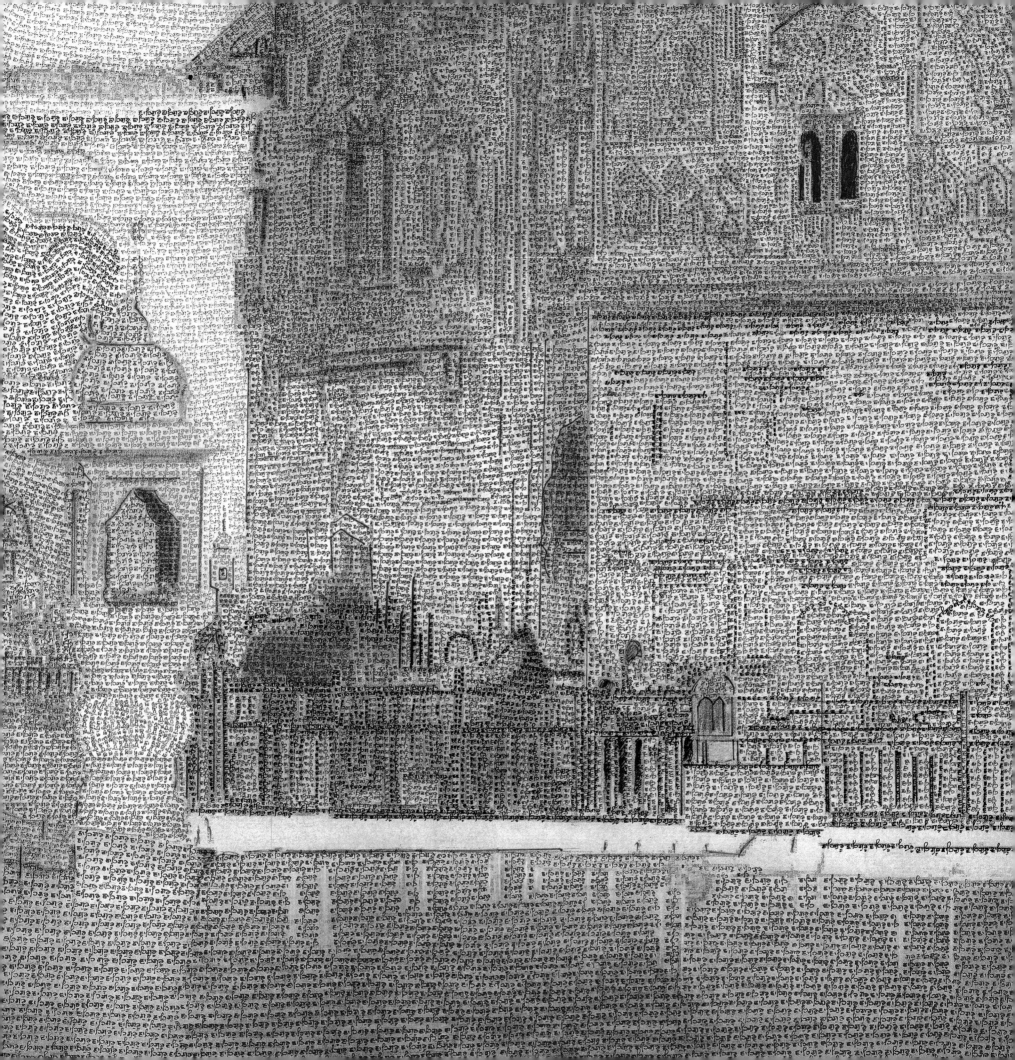

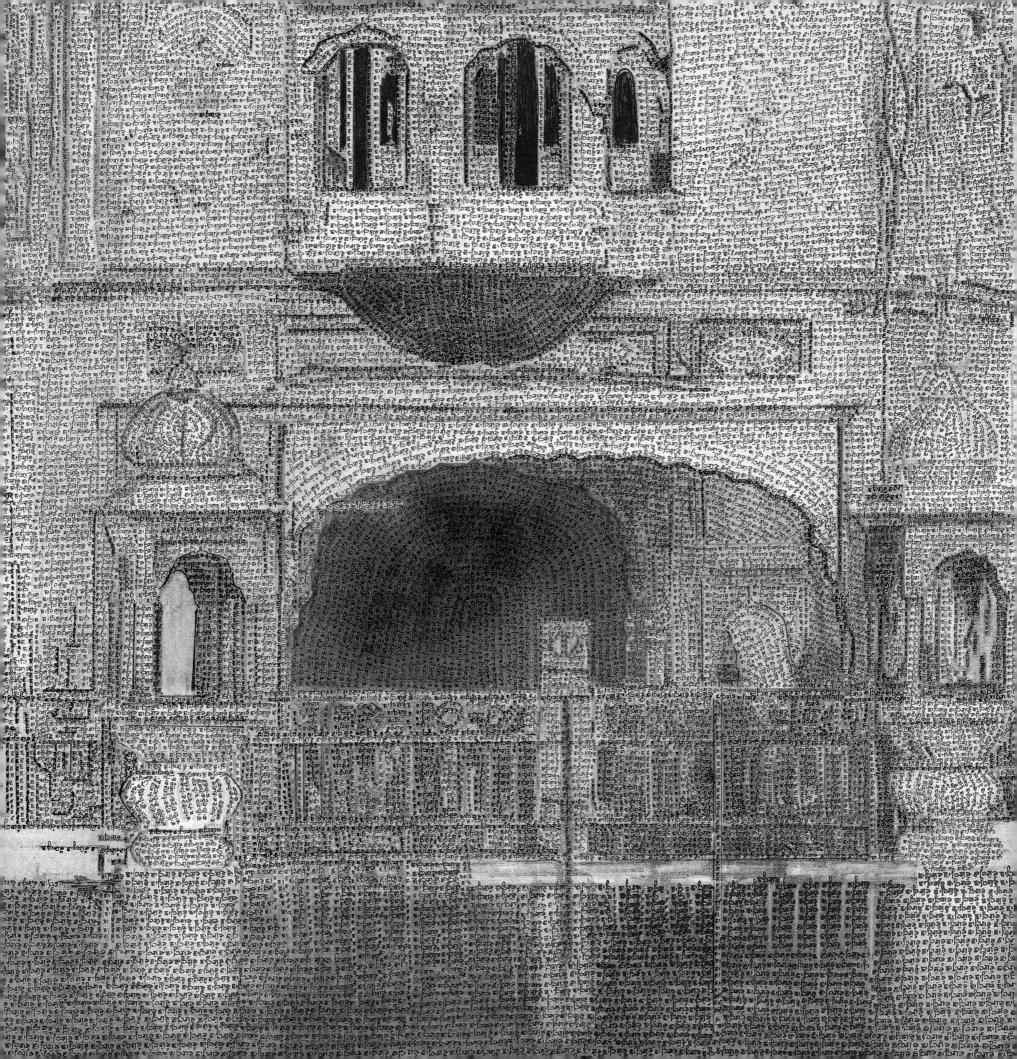

Discovery of Mantra Art

*Inspiration is a message-in-a-bottle from the distant shore,
a window into the other world, a tap of the muse's finger,
the grace of the gods. It comes when you least expect it.*

– Phil Cousineau

By this point, my life had taken a turn towards the religious. I became determined to discover the true essence of *Gurbani*, the message within the Sikh Scriptures, so I increasingly read spiritual literature written by great masters like Professor Puran Singh, Bhai Vir Singh, Joel Goldsmith, Friedrich Nietzsche, Søren Kierkegaard and Tolstoy. I began to nurture my inner monk and surrender to the natural grace and rhythm of my heart's deepest longings. Ultimately, this exploration would lead me back to a deep engagement with the Sikh tradition of my birth.

It was after a ten-day retreat in India that my mantra art journey was sparked.

Back in Montreal in my classroom, as my students were completing a test, I sat at my desk looking around the quiet room. The *Waheguru* ਵਾਹਿਗੁਰੂ chant that had been used for mediation at the retreat was still reverberating in my head. Instinctively, I drew a heart with my fine red pen and started writing the mantra within it, which began to flow into a rather lovely pattern. I followed the curves and filled the entire image. When I finally sat back to look at the resulting creation, I felt quite drawn to it. It reminded me of the particle nature of the universe. All matter can be broken down into increasingly smaller particles, from molecules, to atoms, to electrons and so on. Everything is made of these vibrating particles, this energy. My scientific background was collaborating with the new understanding that suggested that all is part of the One.

That weekend, I drew more of the tiny Waheguru mantra and created the two images seen here.

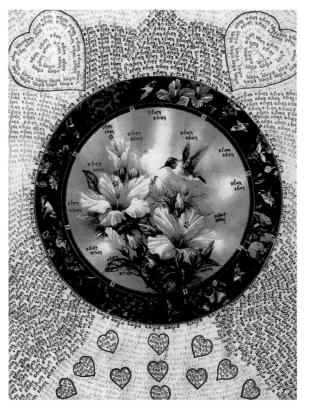

Why the Waheguru Mantra?

The One that pervades the Universe also dwells in the body;
whoever seeks That, finds That there.

– Bhagat Pipa

Waheguru is from the Indo-Aryan language Punjabi, which has roots in Sanskrit. Pronounced *Wah-hay-gu-ru*, it is the mantra given to Sikhs for the purpose of meditation:

Wah is an exclamation of wondrous gratitude to the Infinite

> *hay* means 'Thou' or 'the One'

> *gu* means 'darkness'

> *ru* means 'light'

In other words, 'Wondrous are Thou, the Higher Self / Divine Teacher / Guide Within!'

Each time the Waheguru mantra is either written or contemplated with love, reverence and concentration, one is paying homage to the Divine Teacher within the soul through attuning themselves to the Infinite. This awareness of being one with the universe is what ultimately removes the darkness or curtain of illusion and brings forth an understanding of one's true essence – Pure Consciousness. By chanting and dwelling on a mantra, one gradually realises the presence of the One in every circumstance and in everything. In joy and ecstasy, the egoist self is lost.

Born into the Sikh faith, I was introduced to the Waheguru mantra in my thirties and it immediately resonated within me.

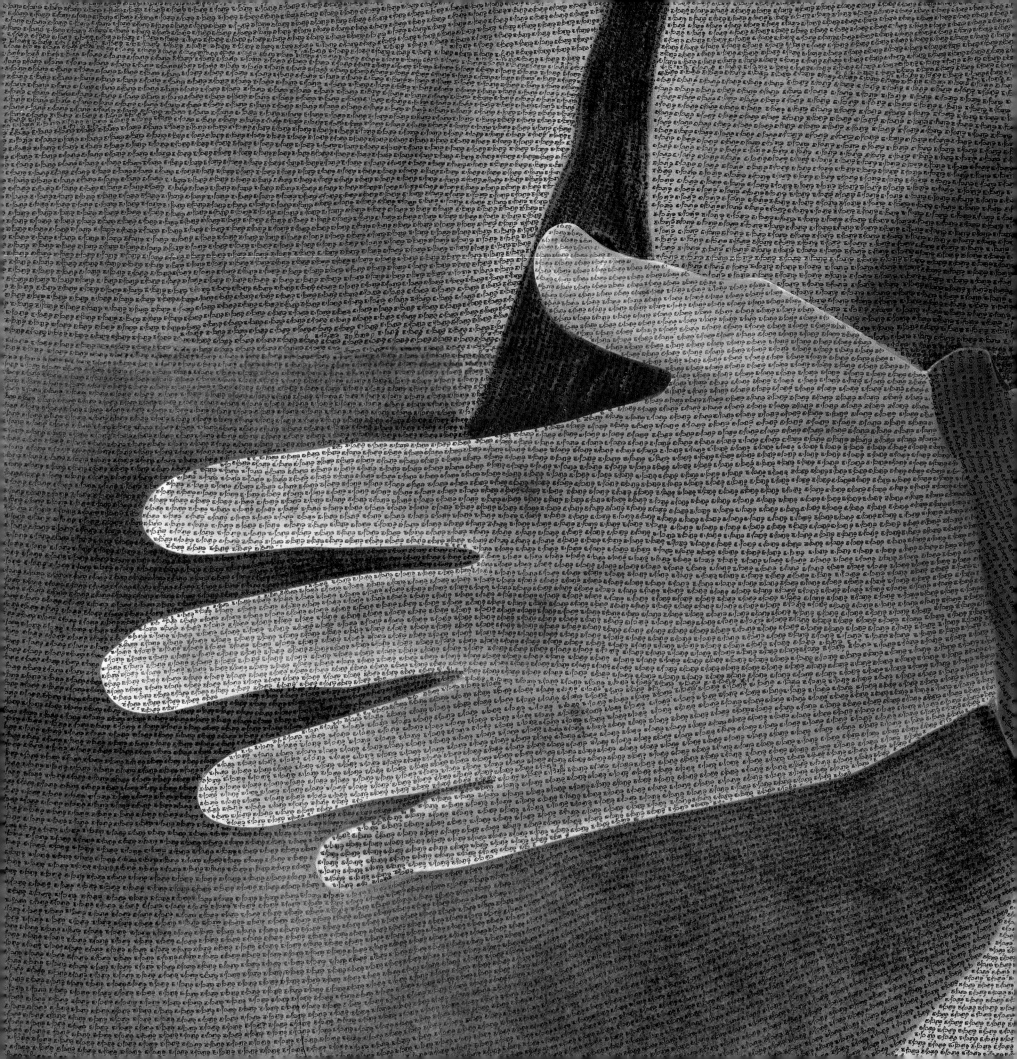

Some Background

*At times our own light goes out and is rekindled
by a spark from another person.
Each of us owes the deepest gratitude to those
who have revived the flame within us.*

– Albert Schweitzer

The youngest in a family of seven, I was born in Nairobi eight years after my immediate older sibling. During this period, Kenya was seeking independence from British rule. My father died of high blood pressure when I was four and my mother courageously kept us all afloat. Despite this, I had to live with several different relatives as she had to travel often to take care of our land in India. As I had a number of 'parents', but not much parenting, I had to learn to fend for myself and become independent. I went to a Sikh faith-based school where I learned about the importance of prayers and how some were to be recited at different periods in the day. These prayers had to be memorised and by doing so, I believe that these daily readings planted within me the initial seeds of mysticism.

I was 13 when I moved to the UK – Kenya had finally become an independent nation and we were given the choice to become British citizens. I was the last of my siblings to leave; the others had migrated already and left me alone once again. The change was turbulent to say the least – a new country, new school, new people, and new ways to learn and adjust to. I was admitted to an English grammar school where I was the only non-white girl. With my independent nature, I quickly learned the norms and values of this new society and started to blend in. I wanted to let go of all formal religious beliefs and separate myself from the traditions of the past as none of it held any real meaning for me.

I think the change was also exacerbated by there being no gurdwara nearby and for years after, I did not attend one. Nevertheless, I always felt that there was something calling or speaking to me – whether it was a voice or a conscience, I am not quite sure. Whether it was from superstition or the doctrines I had learned at school, I found myself repeating 'Kirtan Sohila', a Sikh prayer, by rote every night before I went to sleep.

After meeting B, however, I had a change in attitude towards Sikhism. After years of being away from any kind of formal religious or cultural influence, I was now suddenly awakening to a new life; it was an epiphany of sorts. B changed everything – it was as if he had taken a key, opened up a lock, and allowed the inherent wisdom of the Guru Granth Sahib to begin to open itself up to me gradually,

like the budding of a beautiful flower. It now offered a practical philosophy of life to help attain inner peace and realisation.

The scriptures give just one *hukam* or fundamental commandment: to love everyone as yourself. Although I found joy, hope and comfort in this message, I was not able to put it into practice in my own life. Eventually, when I was exposed to Joel Goldsmith's mysticism in *The Infinite Way and Practicing the Presence*, I discovered some more practical ways of applying the very same principles in everyday situations. Somehow, reading the same message in English from other reliable sources helped me to grasp the meaning better.

I was convinced that by studying different world religions, I would be set upon the path to finding Truth. I reasoned that if I was able to find the same Truths in all of them, then surely those Truths could be trusted. To my astonishment, every time I 'discovered' a Truth elsewhere, I would get an affirmation of the very same thing when I returned to Sikh scriptures. It had been there right under my very nose! I just had not understood it despite reading the same thing several times before. However, once discovered, it seemed to appear everywhere.

Through a combination of my own research and first-hand exposure to B's teachings gave my life a whole new meaning. B had an inner presence that somehow gave him a direct line to the source of Truth. It was as if he was simultaneously in tune with a whole different dimension, and he was simply a pipeline through which a higher source was speaking. I relished being in his presence and in his aura, all problems seemed to disappear. Something in me wanted to remain forever in that glowing, loving ambiance, but I also knew that escaping from the world was not my answer. I realised deep-down that I had to find that mysterious 'something' within myself, and that meant putting in the hard work, dedication, love and devotion. After returning from the first meditative retreat with B in India, my life began to change. More importantly, I had changed.

Death and resurrection do not happen once in a lifetime; this process of birth and re-birth recurs many times over. Every time we have a shift of consciousness, no matter how seemingly insignificant, we become different people. Although we may look the same and our lives may appear not to have changed but, as time goes on, we get further and further away from the life we lived before.

At the retreat, a lot of emphasis had been placed on meditation as an instrument for inner reflection and realisation. After chanting the Waheguru mantra out loud for 40 minutes in the congregation, there was a silent period of 20 minutes reserved for inner contemplation. B urged everyone to meditate daily and to make it an integral part of our lives. Thus, there was nothing more important to me than setting aside enough time to meditate each morning when I returned from the retreat.

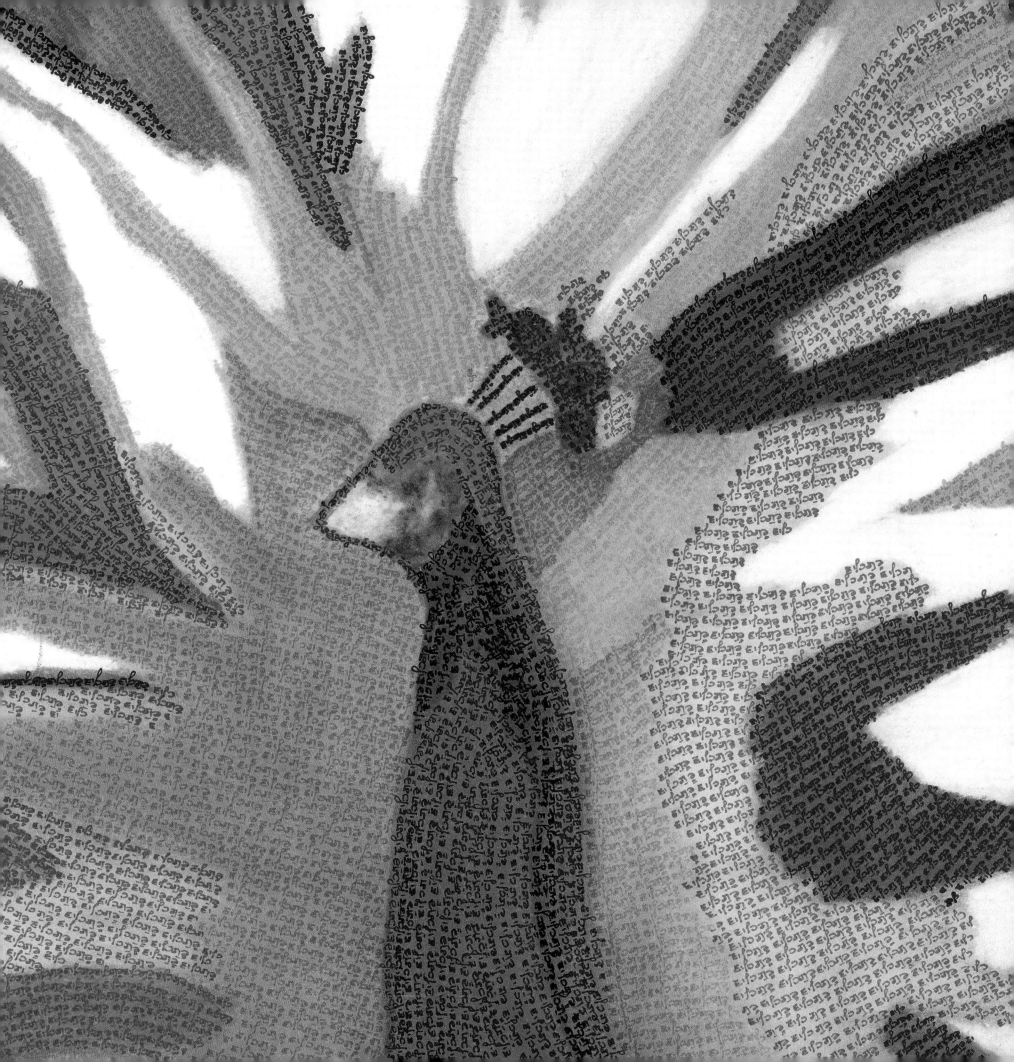

Discipline was already a key component of my life – one benefit of being a teacher is developing structured forms of behaviour from following daily patterns of timed intervals. I relished it, and I found my morning meditations soon became a habitual necessity. This single practice changed my daily life. However, an adverse fallout from this commitment soon followed – I lost many of my friends. Sleeping early became a priority, making most of my previous activities and interests, like going to weekly get togethers, difficult to continue. Fortunately, my immediate family – my three sons and husband – were very supportive and we all became equally invested in this new lifestyle, perhaps because of loving coercion or their own personal calling. I began to develop new interests, including praising the One through song, I became the lead singer in the congregation, went to every possible spiritual retreat, and immersed myself in doing *seva* (selfless-service) with the belief that all of this was somehow bringing me the One's favour. I began to enjoy the stillness of solitude and during my lunch period at school, I began to make portraits of all the enlightened masters and philosophers who had influenced my consciousness. This was a precious time for me and I wanted to have them surround me.

This continued for the next 11 years. As time went by, I realised that doing true altruistic seva was indeed very difficult – something that B had warned me about a long time ago. My self was always tied to its two constant companions – ego and jealousy. No matter how hard I tried to let them go, I failed miserably.

Outwardly, I appeared to be constantly smiling; a shining beacon of positivity to others. But inside I was consumed by anguish and felt dispirited, victimised, lonely and vulnerable – my spiritual journey had ground to a halt. I was stuck on repeat, stagnating, marching on a single spot and not progressing. There was no one to blame but myself. I was stuck in a self-created pit of quicksand, and the harder I struggled and kicked around to escape, the deeper I sank into it.

My meditations seemed forced and devoid of any benefit. I felt completely empty and began to seriously question all that I was surrounding myself with. I heard and understood the messages at an intellectual level, but failed to apply them and to realise them in my own consciousness. The ego conjures up situations that break our concentration and distracts us from our higher intentions. I later understood that these situations are temptations; we should use and turn them into positive ventures rather than be used by them. At times, when coping with negative energy, we can drift deeper inside ourselves and this experience can bring forth more revelations about ourselves. Often, B would say that there was no one to really hear the One's message, and this was a prime example of it. I was deaf to It's words.

A profound turning point then materialised, which changed the course of my life once again.

Help was sent to me.

The Monastery

To live a pure unselfish life,
one must count nothing as one's own
in the midst of abundance.

– the Buddha

I had nurtured a childhood dream of becoming a doctor and I was on the path to becoming one but, seeing my rebellious, independent nature, my family somehow convinced me to get married when I was just 21. Before marriage, I persuaded my husband to promise me that I would be able to continue my education and obtain my Bachelor of Science degree with a major in Chemistry and, later, pursue my dream of a doctorate. So, I was absolutely thrilled when I was offered a scholarship for a Doctor of Philosophy in Education at Oxford University. At that point I was 47 and had already worked as a secondary school teacher for 25 years. Although I still loved and was passionate about teaching, I knew I had to take this opportunity.

My children had grown up by then, so in spite of cultural gatekeepers and family responsibilities, I left for the UK. Although I had to resign from a job I was passionate about, I left the comfort of my friends, family, relatives and home for an uncertain future. Intuitively I knew that this was the best thing for me to do for everyone. In order to continue to give love and to be loved, I had to first learn to love myself again.

Leaving the very holy congregation that had helped me start my spiritual journey was extremely difficult, both for myself and others. But I took a leap of faith, voraciously holding onto B's promise that the One was always with me. However, leaving everything and everyone behind was not without issues and I felt much guilt.

The most wonderful thing happened after about three months of my stay in the UK. I was struggling to adapt and feeling quite sad, still blinded by the 'FOG' of fear, obligation and guilt. Desperate to see B, but not having enough money, didn't help. Serendipitously, someone deposited £900 into my bank account. I was astounded. I knew it was not my money and, after checking with family members to make sure it was not them, I called the bank and informed them about the mistake. They were adamant that the money transferred was mine. Rather than contesting it, I instead used the money to travel to see B and had the joy of spending a week at his residence.

There was neither any discussion nor reprimands from B for leaving the congregation and my family behind, something I felt I deserved. Instead, I received

only love. In his gracious presence, I started to feel relieved and cleansed; I could now 'see' beyond the FOG. I sat outside his room and sang my heart out, choosing hymns from the Guru Granth Sahib that alluded to my state of confusion. I knew B was more than a man – he was a state of Consciousness, an illuminated soul. When I left, his last words to me as he rested his hand reassuringly on my shoulder were, 'I will go with you!'

That was the last time I saw him. He left his earthly abode the following month. While he may have physically left this human plane of existence, the Consciousness he represented remains in force. He continues to remain with me and is to this day an integral part of my life. To the degree we are affected by the consciousness of an enlightened soul, it continues to work in and through us. All we have to do is to tune in at the same frequency.

Following my visit to his residence, I returned to the UK and put all my heart and soul into my studies. I felt reborn. I was living in the university's residence and all around me were ancient, sacred buildings that were once used as monasteries by monks who came to study with a master. Solitude and silence became my constant companions. I felt surrounded by a ubiquitous loving presence.

About six months later, the bank called me to say that a mistake had indeed been made and I would have to pay the money back. Since it was their own fault, they graciously agreed to allow me to pay them back a nominal amount each month, which I paid off within a year. I was finally in high spirits. I had finished my Master's thesis; an especially great feat considering that I had not written anything for 25 years – my first paper of only 500 words had taken me three days to write! On my way to class every morning, I would walk through a lovely park and pass by a tree trunk that had fallen to the ground. Curiously, branches continued to grow from the fallen trunk. Each time I saw it, I would say to it: 'If you can do it, so can I!'

I have always loved trees and their divinity. No matter what confronts them, they remain rooted. I resolved to emulate their uplifting energy. Surrounded and influenced by the great minds of my colleagues, I too began to follow their lead – I read, wrote and began to understand their insights, which helped me to learn the process of writing papers. My final doctoral thesis was over 80,000 words! Deep and meaningful relationships developed during this time that formed an integral part of my consciousness. I learned from my new friends about being in the moment. I didn't have to be on a stage or be someone that I thought people wanted me to be. I could just be me. No more masks.

However, new challenges now arose connected to the intellectual knowledge and capital that I was beginning to accumulate as a student. My critical-thinking tools developed and I was learning to apply these to everyday situations in my life as

well as my faith. The very foundations that I had constructed my whole life upon were being questioned and my previously held beliefs were crumbling to leave a gaping void. However, help comes in all sorts of ways and at exactly the right time.

An intimate friend who was particularly blessed with spiritual insights pointed out that the ability to question everything was just another tool in our arsenal. We all possess a bag, he explained, filled with a number of tools to help us deal and manage our lives, such as how to cook, clean and eat. When a particular situation arises, we reach out for the right tool to deal with it. He asked me a simple question: 'Would you use a hammer to screw in a nail?' In other words, although it is necessary to acquire a set of tools that would serve many different purposes, it is also important to be mindful about the context and how, when and why the tools can be used.

So, my critical-thinking skills had to be used when required, for example in academic environments. They did not have to be applied in every situation all of the time, especially when it came to faith. Analytical thinking can destroy the very foundation of faith, which belies questioning; you either believe in it or you don't. Right in the middle of an ordinary life, magic can happen. Roald Dahl puts it beautifully: 'Those who don't believe in magic will never find it.' I did. I found the magic and it transferred my weeping, tired, heavy soul into a dancer, a scholar, a lover and a painter.

All through this, as I struggled to make everyone happy, I tried to find my own happiness in my painting. Eventually I made an art studio in the basement of my home and found myself spending an increasing amount of time working in there. I had found consolation in my quiet place again.

It resulted in the first of my larger mantra art works. The Tree of Love (page 42) was followed by Spiritual Blossoming (page 50) and The Two Worlds (page 46). By this point, I was being guided by the universal truths I had discovered across the many spiritual texts I chose as companions. They were finally manifesting themselves for me in real life and I was beginning to truly understand that happiness does not come from an outer source but from within. This was something that B had emphatically emphasised but I had never managed to internalise the message. Gradually I had now started to realise that no other person, condition or place could grant me peace and joy. As the inner fountain of nectar starts flowing, the consciousness unfolds itself to reveal that there is no one to please, nowhere to go, nothing to do but to let things happen in the flow. Only when the struggles begin to end, the ego begins to fade and peace, acceptance and joy follow. This was by no means the destination but simply an ongoing journey where gradually, intuitively, I was realising that I was looking for my beloved elsewhere when he was already with me.

My three sons grew to play an intrinsic role in my art. The eldest was instrumental in planting the seed of making my art available to others; something I had never considered before. The youngest, always offering practical advice, charted out a plan for me to make a series of mantra art paintings. The middle one became my best critic and forced me to re-evaluate my choices constantly, even going so far as to scrutinise the lines when I was painting Harmandir Sahib (page 54) to ensure they were straight. The creation process helped to bring me into the present moment and, being thus engaged, I forgot all my inner struggles. All I could think about was the freedom I finally felt and the sense of the One's ever-present love.

First Exhibition

*I have so much to do that I shall spend
the first three hours in prayer.*

– Martin Luther

A close friend constantly reminded me to love both the divine and the personal in order to close the gap between the two and finally eliminate duality. Instead, I had the tendency to be one-sided and to throw the baby away with the bath water. Accustoming back to family life had been tough and it was also difficult re-joining my congregation – after being away for almost ten years, things were different, yet the same.

According to Sikh philosophy, attending a congregation is considered to be a powerful tool for one's personal spiritual quest. In an atmosphere of higher vibrations of other enlightened souls in the congregation, the seekers are able to fly on the wings of giants to help find their own inner path more easily than by being alone. I deeply respect this notion and have experienced powerful feelings while attending congregation several times over the years. With the intention to love, serve and share all the happiness that I had received, I once again became involved in the congregation.

My only problem was that I had trouble conforming to some of the imposed rules and regulations that seemed to contradict all that my consciousness had revealed to me thus far; but thankfully I was able to recognise these as simple blocks and go beyond them. Miraculously, when it came to my art, there were no contradictions and time spent writing the mantra ultimately became my saving grace.

My first exhibition was at the Promenade Gallery in Toronto. The owner, herself a very successful and business-oriented artist, gave me some advice for which I will be forever grateful – that mantra art was a unique concept and that I should continue to develop it. I appreciated her encouragement and put my heart and soul into creating the Reflective Mantra Art series. Since then, I have had several shows and exhibitions, each bringing with it new revelations. I also learnt to use social media to share these gifts. Viewers and visitors have further rewarded me with blessings by connecting with the vibrational energy of each piece. Mantra art has given me the opportunity to 'practice the presence' – to contemplate on the omnipresence, omnipotence and omniscience of the Divine. It has made me realise that I am a Child of God and, as my divine inheritance, it has brought me joy, grace, love and acceptance of life and its various stages. These attributes have now become my companions on this magnificent journey – one that I now know

will never end. I love being with my family, I still go to congregation, I still have my educational roles as a consultant but most importantly, this unfolding has granted me a sense of constant gratefulness for the present moment. I continue to joyfully feel B's presence with me every step of the way.

Hand in hand, we journey on.

An Invitation

If you want to find the secrets of the universe,
think in terms of energy, frequency and vibration.

– Nikola Tesla

I believe that the whole world is, in fact, a text of sacred revelation.

The joy of handwriting thousands of the Waheguru mantra on a canvas is thus a testimonial to the teachings of many divine masters, including, to name just a few, Guru Nanak, Jesus, Krishna, Buddha and Lao Tzu. They have all revealed the same truth – that the Creator is in everything and can be found everywhere. Like a drop of water in the ocean, all matter is already swimming and immersed in the Divine Consciousness. All experience has the potential to be revelatory – all we have to do is to listen, to attune ourselves to the seductive unending song within and without, and to experience the ancient contemplative practice of listening deeply for the still, small voice that calls out to the Beloved.

Ek Onkar – One-in-All and the All-in-One.

In this book, I share the inspiration and significance of each of my paintings in the order they appeared in my journey. It often started with just a thought, a quote or something I had read about. Lingering, fomenting within my mind, at times up to six months, it would begin to drive me onwards before finally exploding into reality.

Each section describes the significance of the paintings before enlightening on the events occurring in my journey at that particular time.

I am most grateful for the opportunity to create this book. It has offered me a period of deep healing and spiritual introspection, a time to try and fully immerse myself in contemplation, meditation and silence.

A glorious pilgrimage within.

What joy!

Come share the journey with me.

ARTWORKS

THE ROSE

*If we could see the miracle
of a single flower clearly,
our whole life would change.*

— the Buddha

In his book *Long Walk to Freedom*, Nelson Mandela encourages us to shine and to radiate our light fully. By doing so unapologetically, we inspire others around us to unconsciously do the same, emancipating them from their fears. The way flowers bloom reminds me of this audacious nature. Through becoming the very light that gave them birth, they unabashedly display their glory and blossom, both patiently and selflessly. They are independent beings, thriving without expectation or admiration, continuing to flourish, living authentically and holding nothing back. Even when crushed, they leave behind their sweet fragrance.

The poet Professor Puran Singh considered the religion of a flower:

> 'Although set in thorns the rose sends an ocean of fragrance all around …. To exhale fragrance has become its function …. Squeeze it, more fragrance comes from it. Dry it, crush it, distil it, still oceans of fragrance ripple from it. You may treat it in any way, you can never, not even the so-called almighty god, can tear its fragrance from it.'

Thus, the rose's voluptuous beauty and heady fragrance brings to mind the powerful sweetness of love, which is the essence itself of the Divine.

A single red rose can also be considered as symbolising one's mystic centre. Sharp thorns, which initially protect the fragility and fragrance of our soul, are eventually concealed when the rose unfolds the intricate layers of her buds to fully bloom, illustrating the growth of spiritual wisdom.

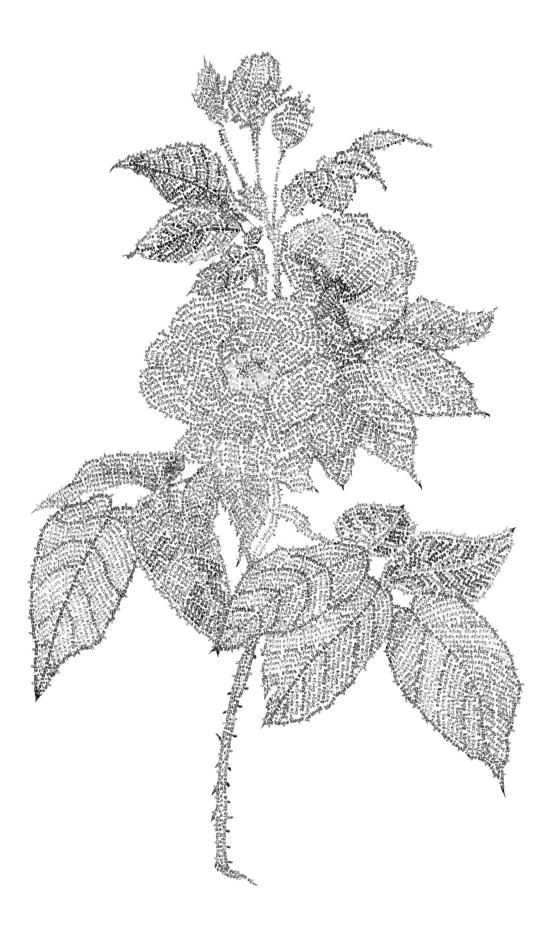

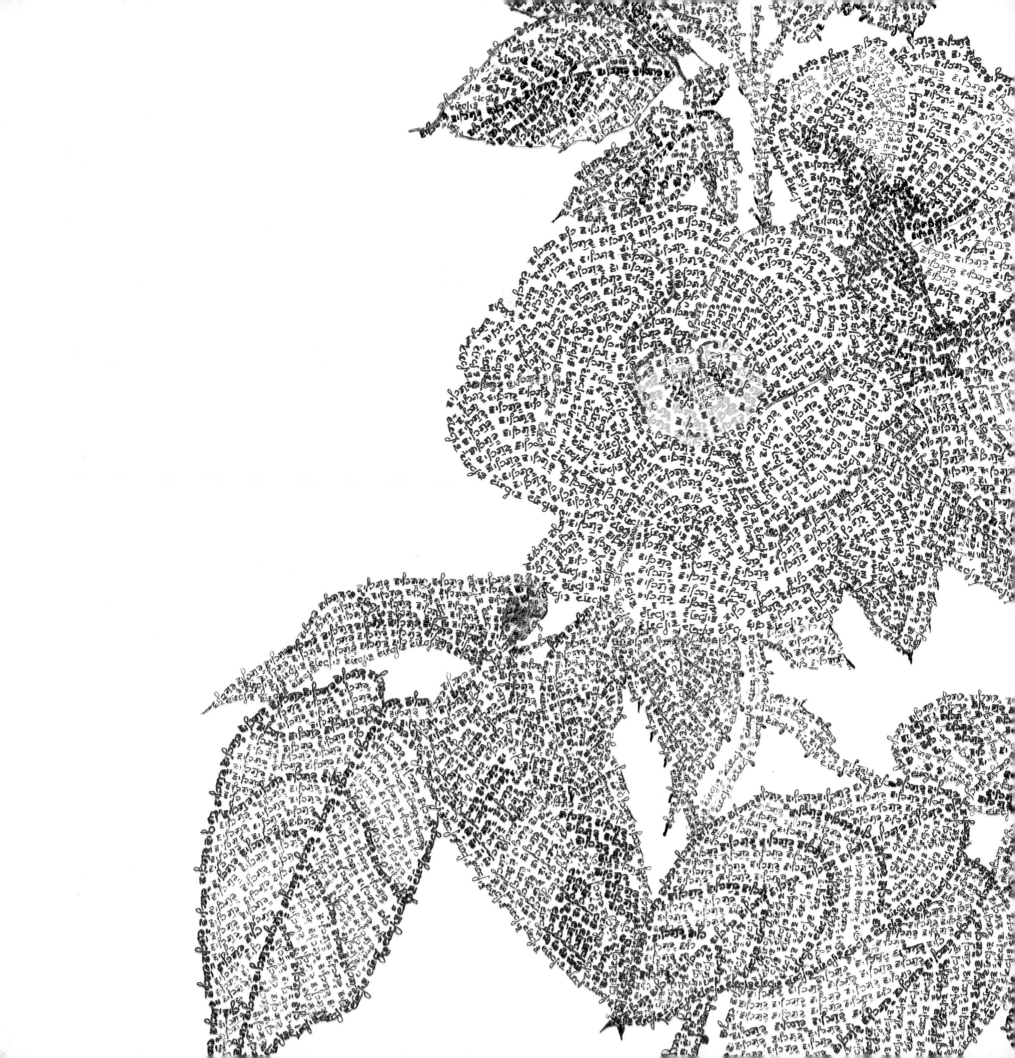

NOTHING TO DO

One morning in Montreal in 2005, during a summer break from Oxford, I was enraptured by a new rose plant growing in our garden. Its intricacy and elegance offered a glimpse of a masterful Creator's active presence in creation. The leaves danced joyfully to the tune of the wind while the red roses waved happily, oblivious to the insects buzzing around it. Contemplating on their carefree beauty, and how they fulfilled their destiny from the blueprint that was integral in the seeds, I became conscious of the vibrating divine energy flowing in each particle of that plant, including the thorns. I knew that the very same light or energy was also instrumental in my own life – both within and around me. For a split second, as I rejoiced in this realisation, I felt all worries about the future dissipate. Like the rose, I too had absolutely nothing to do, for everything was already being looked after.

I had the pleasure of portraying these feelings as I attempted to record the beauty and innate energy of the rose by infusing the piece with the Waheguru mantra. It became a gift for a very special couple on their 25th wedding anniversary.

AUTUMN LEAVES

Without a brush,
The willow paints
the wind.

— Saryu

I love all seasons; each one serves its purpose. However, I find autumn to be a particularly stunning period of time. The glorious colours of the trees never seize to amaze me – each group of trees present a perfect landscape, ready to be painted. As summer transforms slowly to winter, the changing climate and the soft zephyrs feel just right. In its utter brilliance, this season manages to convey messages of inevitable pending change and of acceptance, becoming a constant reminder for us to be mindful in a similar manner: to let go, to relinquish, to renounce and to accept change willingly.

Saint Theresa of Avila observed: 'Just as there are seasons in the world around us, so there are in our interior life.' This is certainly true also of our own physical bodies that constantly shed old cells to create room for new ones. Nothing remains the same because change is necessary for growth and renewal. Autumn is thus a perfect example of the impermanence of everything.

In Tibet, some spiritual masters used to set their teacups upside down before they went to bed each night as a reminder that all life was temporary. And then, upon awaking each morning, they would turn their teacups right side up again with the happy thought, 'I'm still here!' This simple gesture was a wonderful reminder to celebrate every moment of the day. This celebration of being in the moment is illustrated beautifully by the very gaiety of the leaves floating joyfully to the ground.

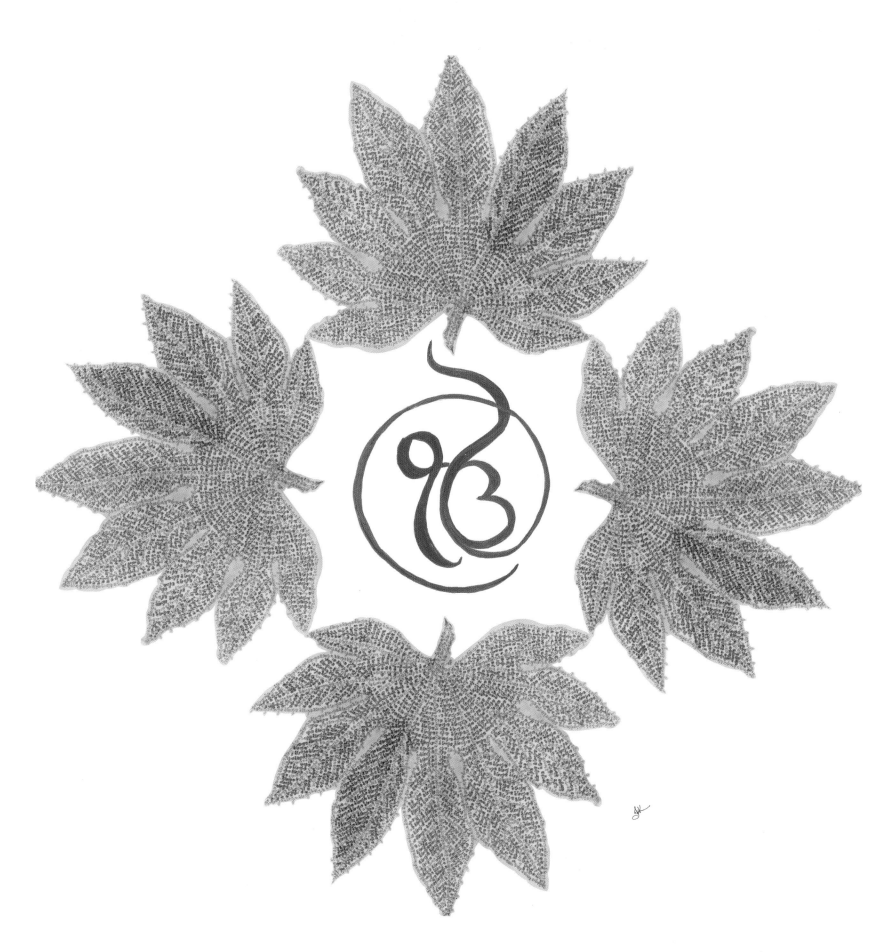

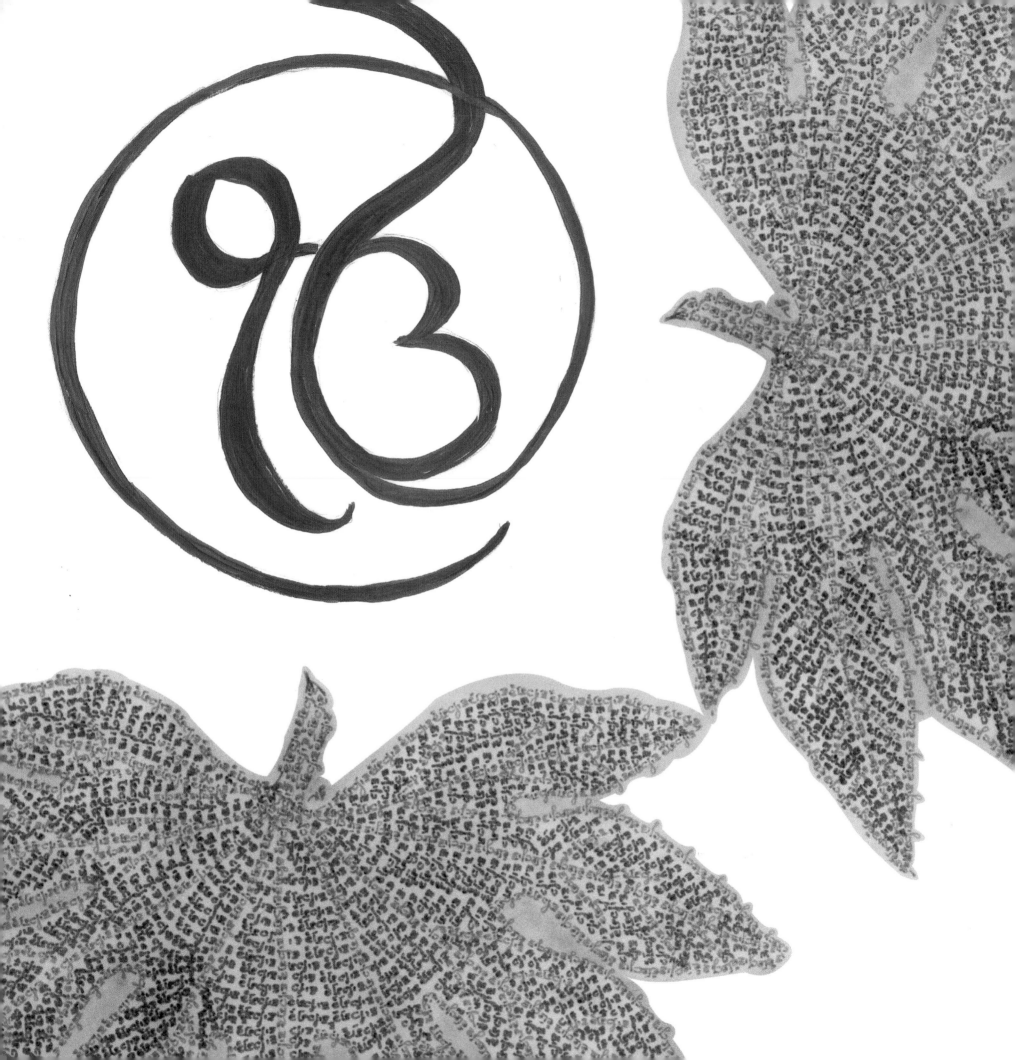

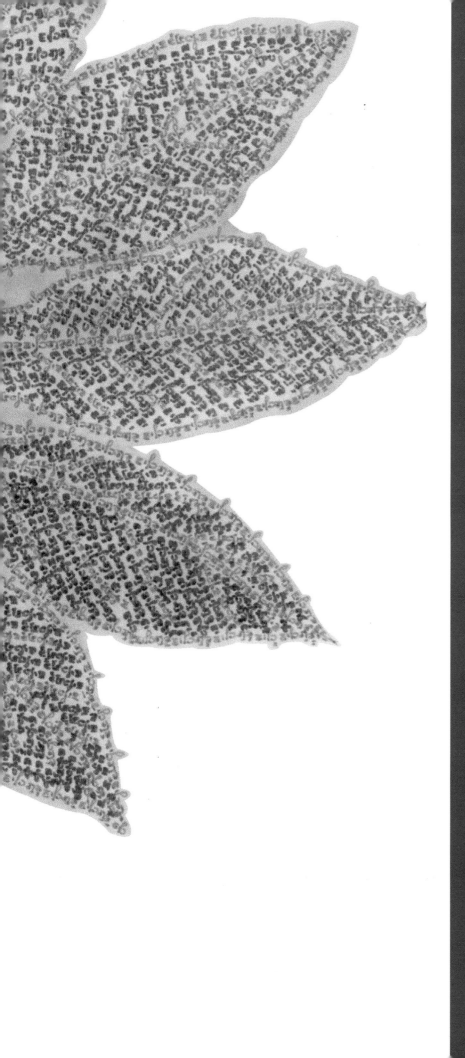

WHO IS 'I'?

When I first moved to Oxford, I went through a pruning of long-held, entrenched ideas, values, desires and needs learnt from my family, community, religion and education. At times painful, I slowly learnt to let go of my attachments, fears, guilt and feelings of obligation so that I could learn to live fully in the moment. In order to allow for a sprouting of new discoveries, there had to be an ongoing and constant shedding of the notion of 'I'. Some of the old ways of doing things no longer worked but, just like falling leaves, they had provided me with a foundation for further growth and fuel for renewal.

Gradually, I developed new aspects of myself that led to changed perspectives and values. In the same way that the trees shed their leaves and undergrowth, realising with full faith that spring will come and encourage new leaves to burst forth, I too was convinced that I could step out into the unknown by trusting the flow – I have never been disappointed.

In this painting, the four leaves depict the four stages of life – infancy, childhood, adolescence and adulthood – that interconnect to form the complete cycle of life. Prompted by Voltaire's wise words of wisdom that 'God is a circle whose centre is everywhere and circumference nowhere', I placed the Sikh symbol Ek Onkar (see page 74) in the centre to represent the omnipresence of the One in each transitory phase of our lives.

SINGLE GREEN LEAF

*Our Lord has written
the promise of resurrection,
not in books alone,
but in every leaf in springtime.*

— Martin Luther

Spring is perhaps the height of nature's vibrant beauty, ushering in a new phase of rebirth and regeneration. This season is conceivably one of the most powerful examples of the brilliance of the Infinite, and it is the green leaf, bringing a sense of energy and renewed vitality, that is to my mind most emblematic of this. It inspires us to regather our strength and refocus our efforts for the year ahead and all the possibilities held within it.

As the philosopher and poet Ralph Waldo Emerson said, every molecule in nature is imperative to create the greater whole. Though the green leaf may be an infinitesimally small part of a much grander whole, it is of vital importance. The leaf acts as a crucial source of nourishment and protection for small creatures and other plants, and provides oxygen for larger animals through photosynthesis.

The Waheguru mantra that constitutes this leaf speaks of the power of the Infinite contained within it, allowing it to fulfil such critical tasks as well as recognising its role within the greater universe.

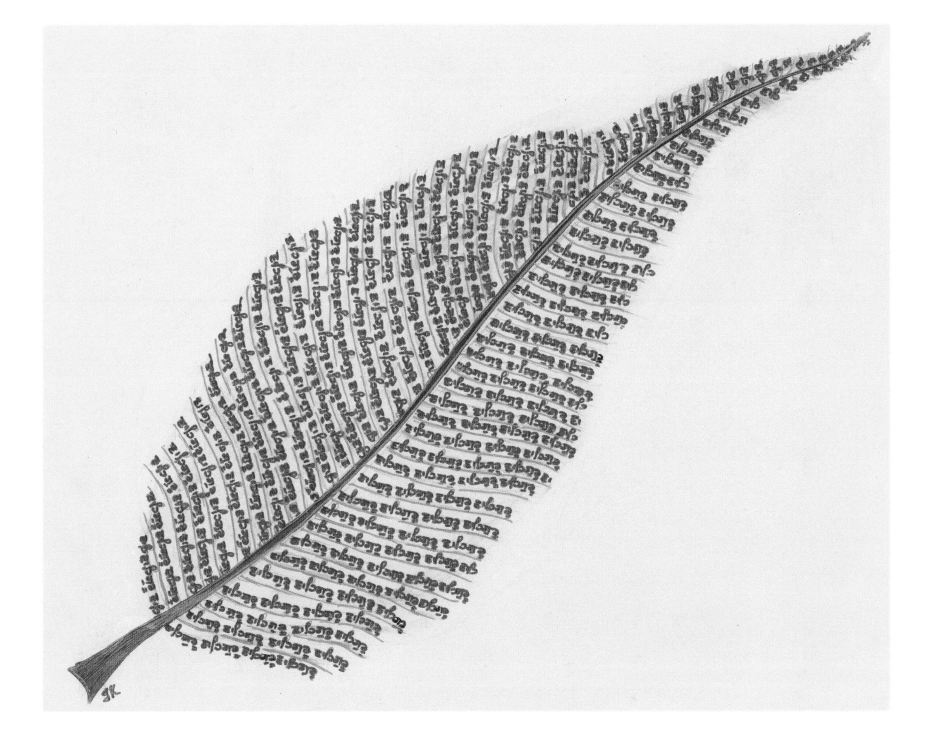

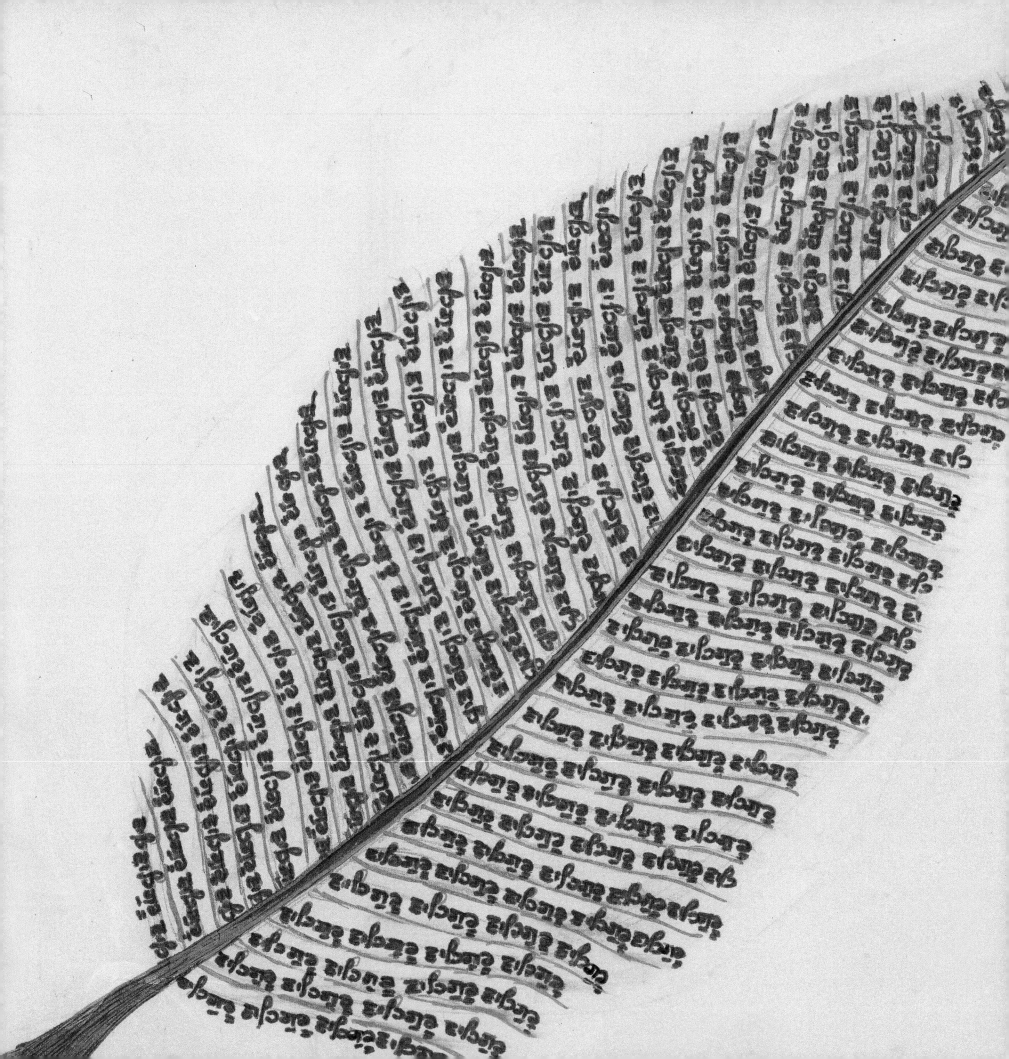

STEPPING INTO THE UNKNOWN

I collect fallen leaves during all seasons; their magnificent colours, intricate patterns and various shapes and sizes never fail to fascinate. Indeed, I fervently wish to paint each and every one of them. Many leaf collections later, I still place them in my books to rediscover them at a later date and to marvel at the glory of the One who created them.

The beautiful city of Oxford is perfect for biking and walking, and during my time there, I did a healthy mix of both. I felt like I was on a pilgrimage as I swished through the thickly-carpeted autumnal pathways created in a breathtakingly gorgeous palette of colours by the fallen leaves. I tried to use all my senses to be mindful of my surroundings – the rich hue of the sky, the crisp feel of the grass and leaves, and the soft scents and textures all around me. By doing this, I was able to constantly renew and refresh my own spirit away from my work.

As leaves descended from the trees, I observed how they served as the foundation for new growth. Fuel for renewal, they allowed fresh leaves to burst forth during spring. Keeping this in mind, as I absorbed new information, I updated aspects of myself, my perceptions and ideas. Realising that some of the old ways of doing things no longer worked, there had to be a constant shedding of who I was to allow a sprouting of new ideas in order to grow from within.

Stepping out into the unknown breeds uncertainty, apprehension and fear. Yet, with a little faith and the right guidance and company of enlightened souls, it gives rise to change that ultimately steers you towards an intuitional understanding of what it means to have a peaceful life.

FOUR LEAVES

*Nature will bear the closest inspection.
She invites us to lay our eye level with her
smallest leaf, and take an insect view
of its plain.*

— Henry David Thoreau

It is traditionally held that four leaves, like a four-leaf clover, bring good luck to their collectors. In addition, each leaf is believed to represent something different:

- the first is for faith
- the second is for hope
- the third is for love
- the fourth is for luck

The joyous sounds of leaves rumbling in the winds call out endlessly, imploring us to join in the Eternal Song and Dance.

All matter in the universe is constructed from the same atoms and molecules. Therefore, the first step in connecting our body with nature is realising that we are an integral part of nature rather than separate from it. By deepening our connection with nature, we allow ourselves to connect with the creative spirit that can only bring immeasurable rewards.

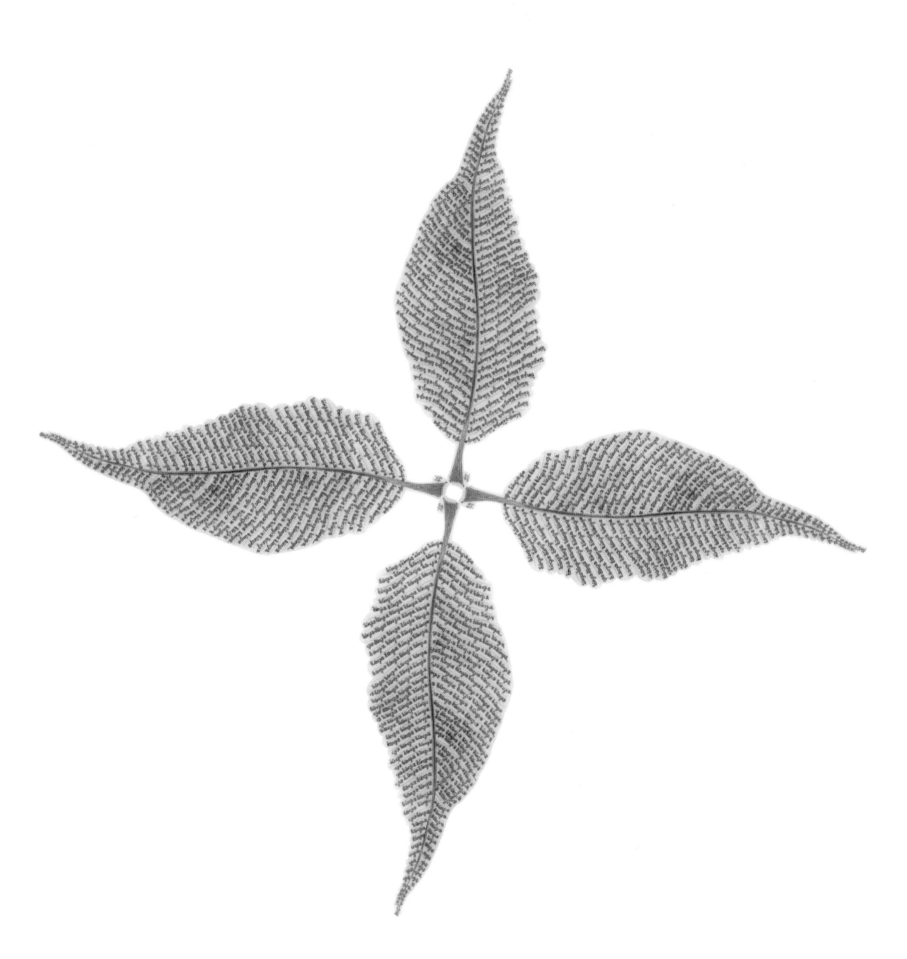

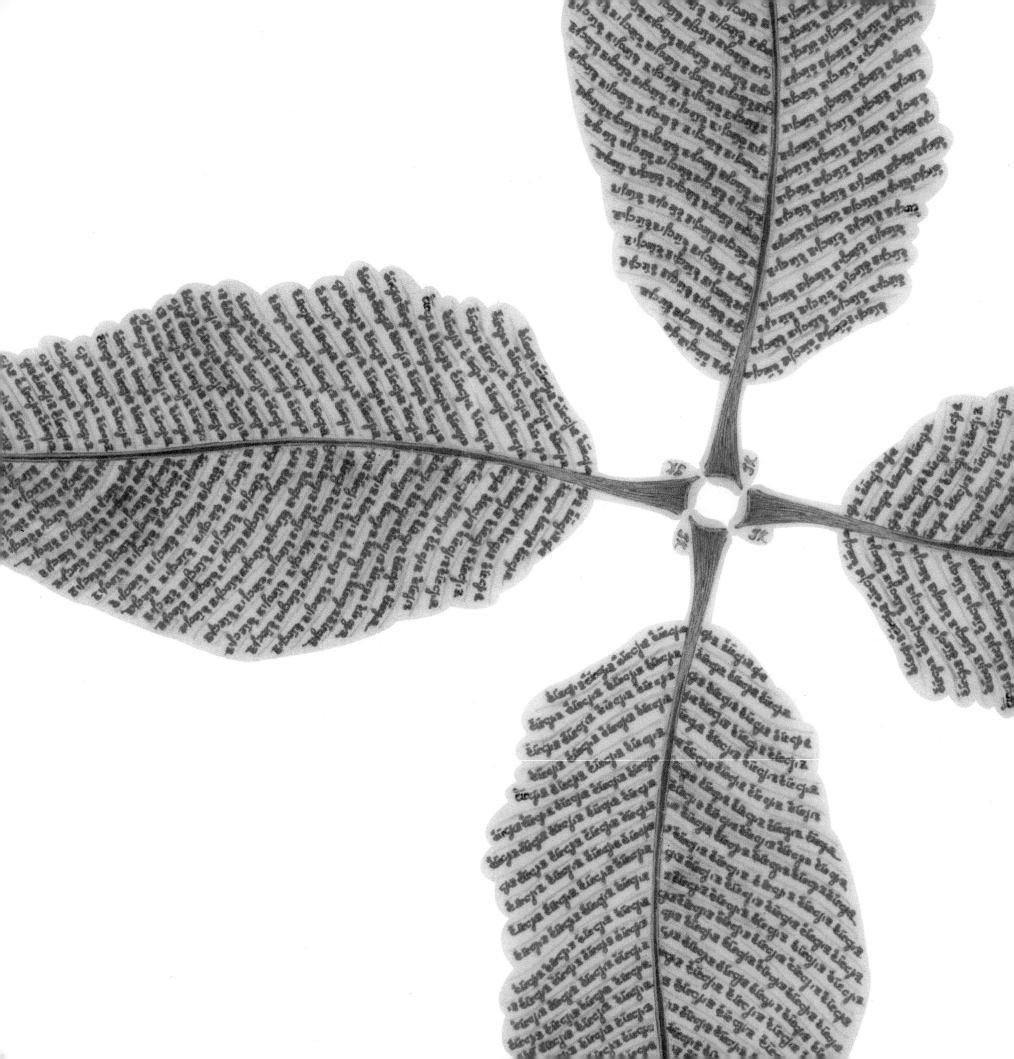

TO FLOW IS TO GROW

Leaves have a magical effect on me. With their intricate fabrication emanating a sense of deep peace, each and every leaf never fails to fascinate and enrapture.

Each spring I would try to catch the moment when tiny buds begin to unfurl into spirals before growing into full-fledged leaves. I would attempt to take pictures documenting their birth but somehow, I would always miss the exact moment they unfolded. It seemed they bloomed overnight. The songs that the leaves whispered, each dancing freely to the tune of the wind, reminded me to do the same – to continually sing and dance to the Eternal Song.

Life was teaching me precious lessons during this blessed period of solitude – I had never taken time to be alone before. Always surrounded by people with their endless lists of things to do, I never seemed to find the time to listen to the voice within. Now, finally immersed in nature, I was beginning to consciously become aware of, and enjoying, the ubiquitous flow that connects everything. The insights that were flowering were effectively replacing learnt beliefs about the Infinite Being. Suddenly there was a whole new dimension; I was beginning to realise that there is a divine process, just like photosynthesis, that transforms everything to enable growth. I was not only the Divine Dancer but part of the Divine Dance itself. The One is everywhere and in everything. Just like flowing water, nothing stays the same and change is inevitable. When we finally become part of the flow we realise that it too was needed for growth.

HOPE

*Hope is the thing with feathers
that perches in the soul and sings the tunes
without the words and never stops at all.*

— Emily Dickinson

Each new dawn brings hope, fresh insights and inner transformation. Hope is one word that defies a singular definition – it can mean anything one wants. For me, hope is found through meditation and contemplation on the universal truths. The Persian poet Rumi says it most eloquently:

'It is the scent of home that keeps me going, the hope of union, the face of my beloved.'

Hope is not wishful or magical thinking; it is a source of strength and renewal, an 'invincible summer within' as Albert Camus beautifully puts it. The gift of hope is what allows us to transcend the Self, to live mindfully in the moment, and to believe in the unknown by becoming still enough to allow things to simply be. Instead of being tormented by worries about the future, why not focus on what we can do today to make tomorrow a better reality?

WATER AS TEACHER

Hope as a spiritual practice became a remedy for existentialism and nihilism. During my time at Oxford, many challenging situations arose but somehow things always seemed to resolve themselves. By learning to focus on the present and continuously replacing every negative thought with a positive one in the face of adverse situations proved to be very effective. This was something that B had instilled in me through his loving talks and writings.

The anxiety and anguish that usually results from worrying about problematic scenarios would disappear as I practiced staying in the moment and concentrated on absorbing myself in more mundane tasks, like organising old photos or jewellery. On reflection, I now understand why this was such a helpful technique – it was a method of disempowering the situation brewing in the mind. By relinquishing control and becoming consciously aware, even for a moment, that my adversity was just an illusion, my anxieties dissipated. How could any darkness exist in the Divine Light?

Over time I have come to realise that to be still means to not even hope for a desired situation. To be in tune with the Divine Will means to go with the flow and be happy about all that is happening. Think about river water flowing simply with the current and circumventing obstacles. Even if it becomes stuck in a whirlpool, a strong enough current will eventually push it forward until the water finally meets its source.

I find great joy in observing water, whether it is by sitting on a river bank or at the beach. It has a magical effect on the soul – what a great teacher!

SILVER LINING

*There are always flowers
for those who want to see them.*

— Henri Matisse

The beauty of life is contained in its strange, wondrous nature and its delicate intricacies. It would be a dull world if we had to look up at cloudless monotony day after day. In the same way, a balance in our lives helps us truly appreciate what we have; like our joys tempered by grief. It took me years to realise this truth. When the sky (or my life) is filled with clouds, I become conscious that they are temporary and all that is required is a little acceptance and patience for things to change. While I wait, I take simple pleasure in knowing that behind the darkest of clouds the Sun is still shining.

I love the story that Charles Schulz illustrates in his comic strip *The Complete Peanuts* in which Lucy, Linus and Charlie Brown are staring up at clouds. When asked what each sees in them, Linus, the smartest out of all the characters, imagines that he sees a map of British Honduras in the clouds. He also sees the famous painter, photographer and sculptor, Thomas Eakins, and the apostle, Paul! Lucy, on the other hand, sees big balls of cotton. When Charlie Brown is asked, he sheepishly admits that he was seeing a 'duckie' and a 'horsie'!

Our perspective is key.

LOOK UP

The saying 'Every cloud has a silver lining' was the inspiration behind this painting. My older brother was seriously ill and I wanted to send him encouraging vibrations to help him through this transitory state. As an intellectual, the limited mobility and the inability to read were major setbacks for him. What could bring him inner peace and acceptance in this confusing and difficult situation? Where exactly was his silver lining? It came shining through in the way the whole family rallied together to find unconventional ways for him to read and move.

While writing my thesis, dark clouds would often loom – deadlines, unsuccessful ideas, challenging presentations and so on. At the beginning they were quite draining but I was helped back onto the path by advice from a loving friend, a kindred spirit who somehow always understood how I was feeling. 'Look up,' he would say. At first, I started to literally look up from my laptop every hour and breathe deeply before getting back to work. This didn't help much until I understood what 'looking up' really meant. I disconnected momentarily from the working energy in which I would be totally absorbed, stopping to consciously get back in the present moment and to realise that it was not I who was working. Although difficult at first, especially when I was in a flow and wanted the momentum to continue, the practice of putting everything in the hands of the Divine became a habit. It became a time to breathe and realise that the Sun was still shining beyond the ominously looming grey clouds.

Now when I 'look up', I stop whatever I am doing, whether it is a stressful period or not, to connect to the inner light within, to feel the Divine Presence and acknowledge who is doing the work.

FLOWER MANDALA

*I bring flowers to weave a garland,
in worshipful adoration of the Master.*

— Bhagat Namdev

A mandala (from the Sanskrit for 'circle' or 'disc') is usually a circular design used to symbolise the never-ending and interconnected nature of life. Mandalas contain special evocative powers, which are often connected to their colour and shape.

Prevalent in nature, they can also be seen in the art of numerous cultures and civilisations across the world: the Aztecs and Mayans, the Celts in Europe, and the Hindus and Buddhists of India have all expressed aspects of themselves through this universal motif.

For the psychoanalyst Carl Jung, a mandala is a method for understanding all our 'whole selves' regardless of where we come from; a tool to reach deeper human consciousness and encourage us to realise true potential.

All mandalas have a number of meanings. On the 'outer' level, they can represent the universe in which we reside and how we relate to it, ie through society, politics and relationships. With the 'inner' mandala, the focus shifts from the material world and attachments to our internal being, to our energies and how we can channel them to find peace and stillness. The final level is the 'secret' mandala because it relates to each individual's own sense of reality – our meditative behaviour helps our sense of awareness and being open. In the purest form of this state, all our emotions are interconnected, allowing the potential for complete freedom, liberation and self-knowledge.

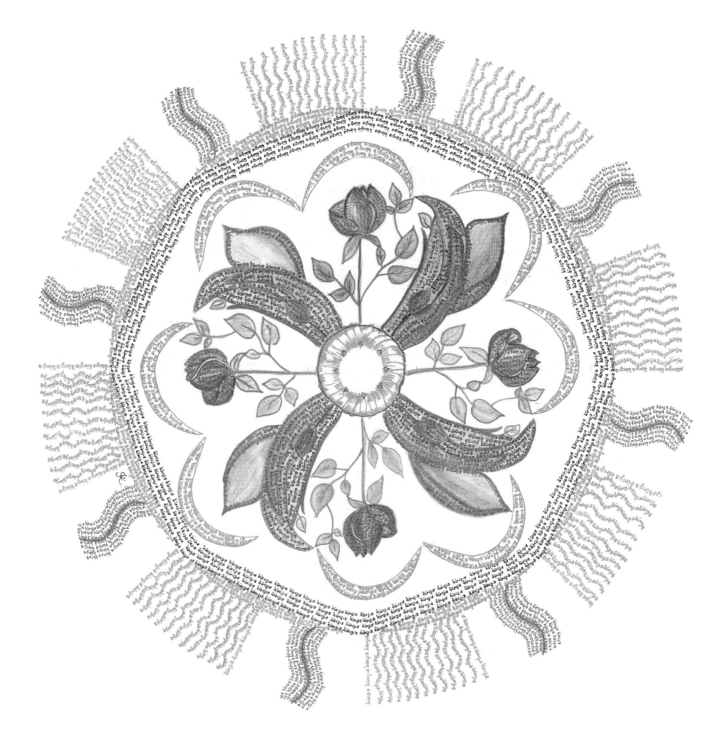

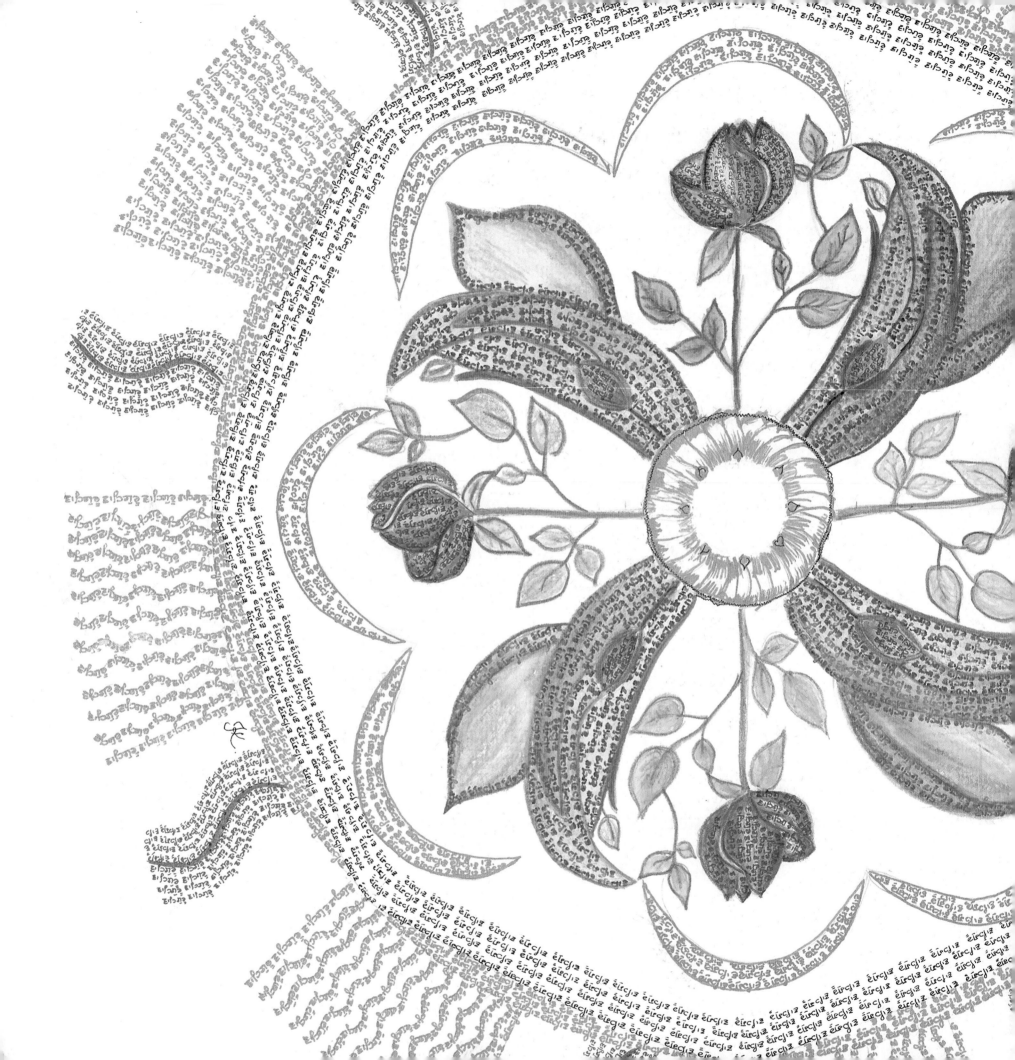

LETTING GO

Drawing upon Rumi's saying to 'remove oneself from the circle of time and into one of love', this mandala represents wholeness, a cosmic diagram reminding us of our relationship to infinity — both within our bodies and minds and then extending further, beyond time, beyond space and beyond the material world.

Recently, a friend bought me a Buddha Board, which allows one to create beautiful images on a water canvas. As the water evaporates, your beautiful creation fades away — a surreal feeling indeed. The Tibetan Buddhists have a practice of making elaborate mandalas out of colourful grains of sand and then destroying them; a practice that leaves me aghast with wonder. How could one create something so beautiful and then destroy it? For me that is the epitome of selflessness. The creation and destruction of the mandala teaches the impermanence of all things; something symbolic of all life. While I still don't have it within me to destroy a work that has been infused with thousands of Waheguru mantra, I wonder if one day I will be able to follow this Tibetan practice. After all, nothing lasts forever and we must all let go.

WEAVING MEMORIES

Weave in red blood,
weave sinews in like ropes,
the senses, sight weave in,
Weave lasting sure,
weave day and night the wet,
the warp, incessant weave, tire not

— Walt Whitman

Our life's journey, like a tapestry, is woven with threads of countless colourful memories, including love and sorrow, pain and ecstasy, self-realisations and epiphanies, and births and deaths of various stages of ourselves as we traverse from childhood through to old age.

Although the physical body changes, the essence within remains and develops with each experience as we internalise it into existing understandings. Each event becomes a needle pulling thread, sewing it into the fabric of our beings.

Later in life, hindsight affords us reflections and a perspective of the present. As we gradually begin to examine the overall designs of the tapestry, we intuitively understand the importance of each occurrence in our lives, regardless of how painful they were at the time. Each one can be recognised as a necessary step towards a place of higher understanding.

We learn to grasp the fact that all the threads are our own consciousness embracing the very essence of life; they are woven into the tapestry of our lives and are equal in value, no matter what their colour is. These threads are instrumental in creating a beautiful tapestry of self-realisation that culminates in an exquisite plan.

THE SILENT LOOM

Weaving memories was inspired by a longing to be in a continuous remembrance of my beloved – a desire to be in communion with the Divine, to sit in Its lap, and to enjoy the love that was permeating everywhere. Intuitively, I wanted my loom to become silent and still, letting the Master Weaver add the dark or the golden threads with Its all-knowing hand. It was a daily exercise to contemplate on the essence within that is closer and more meaningful than breath. Each hand-written Waheguru mantra was like a stitch in time as I recalled my own master and his loving words of guidance.

The ecstasy of experiencing true love is a privilege, an irreplaceable, glorious treasure. However, at times, it does bring with it pangs of non-endurable separation, invisible wounds that in time become a life-reinforcing source. Memories of one's beloved become the blessed muse, they are the wind beneath one's wings, urging the soul to fly home. How does one thank the beloved for appearing in one's consciousness, bringing magic into the ordinary life and furthermore for keeping this magic alive?

FATEH

I bow to You, the Immortal,
I bow to You, the Compassionate,
I bow to You, the Formless;
I bow to You, the Only One.

— Guru Gobind Singh

In this quietly profound salute, folding the palms together in front of the heart is a universal gesture of reverence, helping to connect the head to the heart to instil a moment of reflection. The bowing of the head symbolises the ego surrendering to the deep inner wisdom of the soul, humbling itself to the heart. By bowing to another, we also humble ourselves in recognition of the divinity within them.

When two palms touch, it is believed that in this expression or *mudra*, one hand denotes the higher spiritual nature while the other the worldly self – joining the hands represents an integration of spirit and matter.

Greeting others with folded palms is commonplace in India and across South Asia. For Sikhs, the greeting *Sat Sri Akal* – referring to the true timeless and formless Guru within – is said with folded hands.

Namaste, a customary Hindi word used when greeting or leaving to express mutual goodwill, appreciation and respect, is often used when either 'hello' or 'goodbye' would be used in English – but with a deeper meaning. Namaste, and its more respectful forms *namaskar* and *namastun*, acknowledges that the other is regarded as a teacher who deserves love and respect. Thus, we all have infinite capacity for learning.

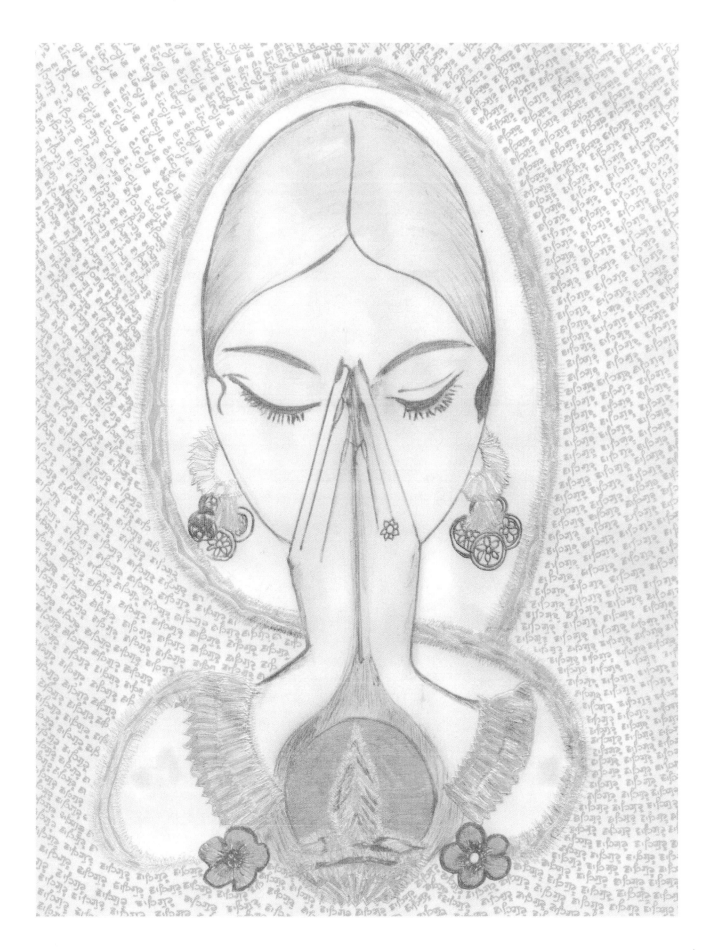

NO NEED TO ASK

In Punjabi, *fateh* means victory, traditionally in battles. For me, it means to be victorious over battles faced in life to fulfil one's purpose. I hung this painting in the entrance of my home as a constant reminder for me to consciously acknowledge the silent but ubiquitous presence of the One in all that I encountered each day – whether it was in a person, in an animal or in a place – and to bow with folded hands to It.

As a child, I had been taught to either pray to the Infinite, or to ask a priest to do so with an offering in order to fulfil my smallest desires. If I was taking an exam, I prayed so that I would pass. If someone was not feeling well, I prayed so that they would get healthy. However, with the dawning of the intuitive understanding that the Infinite Being is omnipresent, omniscient and omnipotent and did not require my limited sense of what was good or bad, I came to realise that actually there was no need to pray, to ask for or make a special requisition for anything. The only prayer that was necessary was to remain still within, simply to be, and then wait for it to unfold, realising that all was exactly the way it should be.

PROTECTIVE EMBRACE

On all four sides
I am surrounded
by the All-Pervasive One's
Circle of Protection;
pain does not afflict me,
O Siblings of Destiny.

— Guru Arjan

When two souls that have a conscious awareness of their individual divinity unite, they merge into the One.

This painting depicts such a couple, hugging each other in a cocoon-like chamber, denoting the loving and protective embrace of the One. With love grounded in the recognition of their own divine spiritual nature, at one with the omnipresent and omnipotent universe, they are surrounded by an ocean of loving vibrations.

This oneness with the Spirit provides an invisible permanent shield of protection even in the worldly realm. They are always surrounded by the One's divine loving embrace in whatever they do; through periods of prosperity as well as during trials and tribulations.

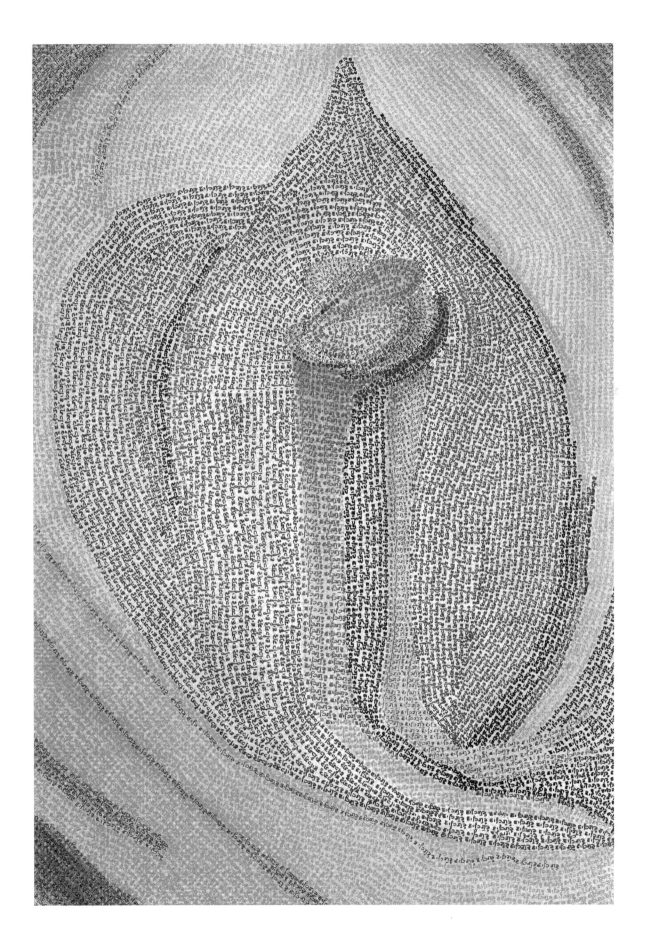

IMMERSION IS KEY

When I returned to Montreal in the summer of 2008, having completed my doctorate, I felt both elated yet sombre. I was delighted to be back with my loving and supporting family – they were extremely proud of what I had accomplished and threw me an amazing surprise welcome back party at a nearby lake resort. However, I missed the intense lifestyle of solitude and concentration that I had cultivated. I was now a changed person.

However, I was grateful that the lessons I had learnt helped me to adjust to this period and keep flowing. I took to painting with a renewed passion – it helped me to focus and to find the stillness within that I had come to cherish. Even though I had found a job, I rejoiced that it was part-time and I had ample time to devote to my art.

This particular painting was made during that time as a gift for a family friend's wedding – a union of two beautiful souls. The Protective Embrace portrayed to me the importance and presence of a spiritual bond between a couple and a poignant reminder: we are always held in the Divine's arms, even during anxious times, as long as our consciousness realises and remains immersed in the Infinite.

THE TREE OF LOVE

The tree of love its roots hath spread
Deep in my heart, and rears its head;
Rich are its fruits: they joy dispense;
Transport the heart, and ravish sense.
In love's sweet swoon to thee I cleave,
Bless'd source of love.

— St Francis of Assisi

Withstanding the greatest of challenges, the tree stands rooted firmly within the flow of time, enduring all types of change, ever-happy to be part of the ocean of the Divine Will.

The Tree of Love is a symbol of life, energy, balance, strength, stability, growth and harmony. Within each of us there exists a tree of love that reaches into the radiant light, representing the journey of our soul. As we cultivate awareness of the universal Consciousness, the symbolic tree spreads its roots of love deep within, bringing with it an aura of warmth and kindness so all that sprouts forth in our lives is positive, including our relationships, our work, and our very existence. As Max Ehrmann hints at in his poem *Desiderata*, we too are children of the universe, no less than the trees and the stars, and the universe is unfolding exactly as it should. All we have to do is be still.

The Tree of Love also serves as a metaphor for how we are all connected through the one Consciousness. We are all individual parts (branches) of a central source (trunk). We are not separate as we appear outwardly. Instead, we are bound together with an invisible force from which we all derive nourishment, love, care and protection. No branch is in conflict with another.

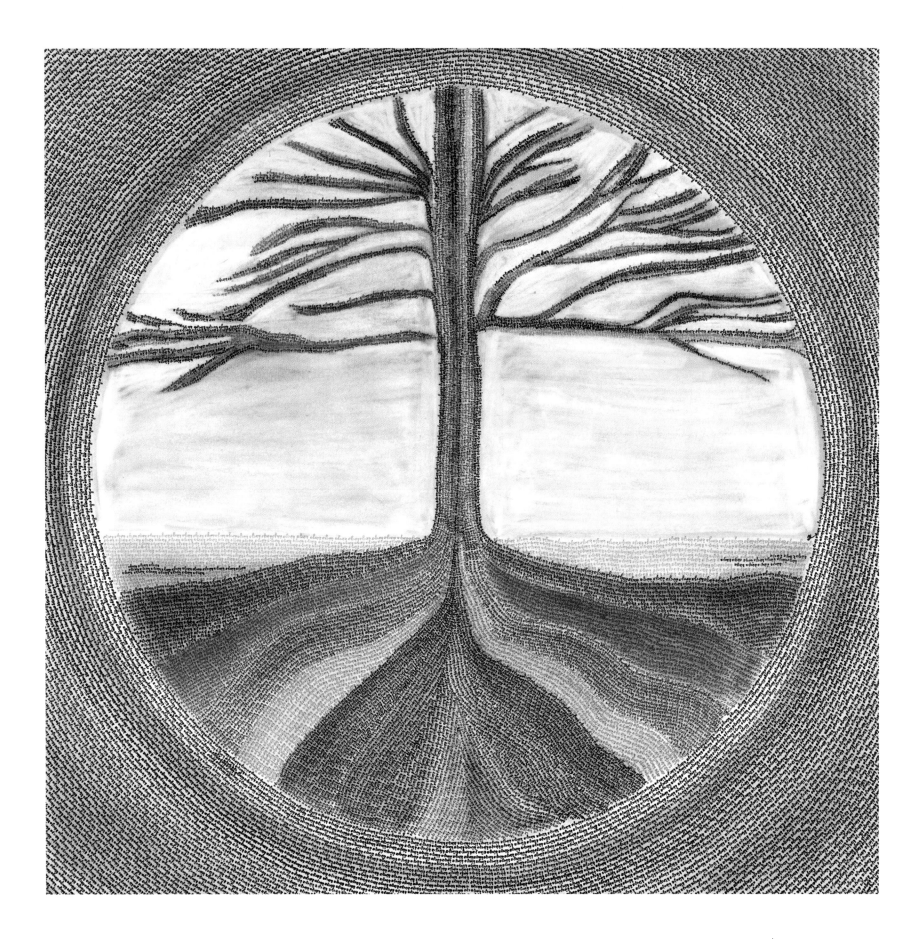

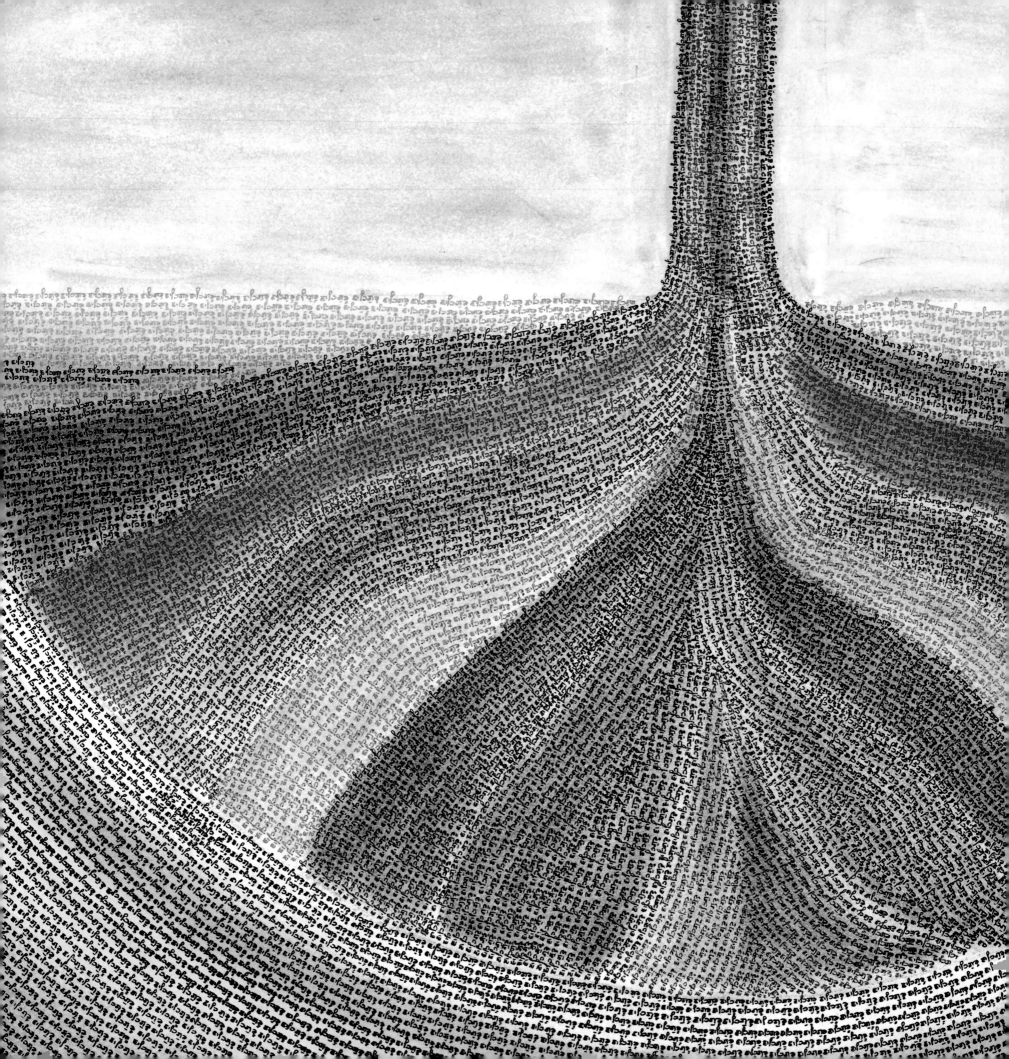

WISDOM KEEPERS

Trees have fascinated me as far back as I can remember, especially when their roots are protruding and they are old with signs of acute weathering. They symbolise a certain spiritual steadfastness: time beings that remain in the Divine Will. I like to think of them as wisdom keepers.

Observing the trees on my daily walks through the park that was a short cut to the Education Department at Oxford, I fervently wished to emulate their steadfastness in all four seasons; dancing and swaying in the winds and singing the Eternal Song through frost and sun, to dance to Its Rhythm and to hear Its Music.

On one such morning, I walked under the tarpaulin-like canopy created by the bowing branches of a giant, ancient willow tree. It was quite warm although the sun was just rising; a soft mist still clung to the surrounding trees, creating a light haze. Drops of dew glistened on its leaves and I felt a protective energy surrounding me. I sat there for a while, listening to the birds and watching a squirrel that was standing upright on a nearby branch with both hands folded. As I got up, it began to perform for me, jumping from branch to branch. All of a sudden, quite impulsively, I found myself singing a verse from the Sikh scriptures: 'I am a sacrifice to Your Creative Power pervading everywhere'. I was acutely conscious of being alive, of being part of an amazingly varied and extraordinarily beautiful creation. With my eyes closed and hands stretched out, bathing in the soft rays of light, I couldn't help but feel the silence and stillness penetrate my very being. It was this very feeling of connectedness that I tried to emulate in The Tree of Love, my first large image. Incidentally, it ended up adorning my son's wedding card in 2012.

THE TWO WORLDS

*Now I do not know whether I was then
a man dreaming I was a butterfly,
or whether I am now a butterfly,
dreaming I am a man.*

— Chuang Tzu

Most world religions teach that material existence is a dream. Thus, an awakening of consciousness is important, helping us to understand that we are not apart from the One, but a part of It. In other words, all we see, hear and feel is an illusion — there is no other space and time beyond the now.

The metamorphosis from a chrysalis to a full-fledged butterfly beautifully illustrates the unfolding of the consciousness. In this transformative stage, the butterfly simply rests while accepting and embracing transition, gaining strength for the next phase.

As our consciousness unfolds, we too find our centre where there is no movement — only stillness. We learn to live in both worlds simultaneously. We are spirit but we are also human. The challenge for us in this lifetime is to appreciate and have allowance for both worlds at the same time while also letting go of the duality.

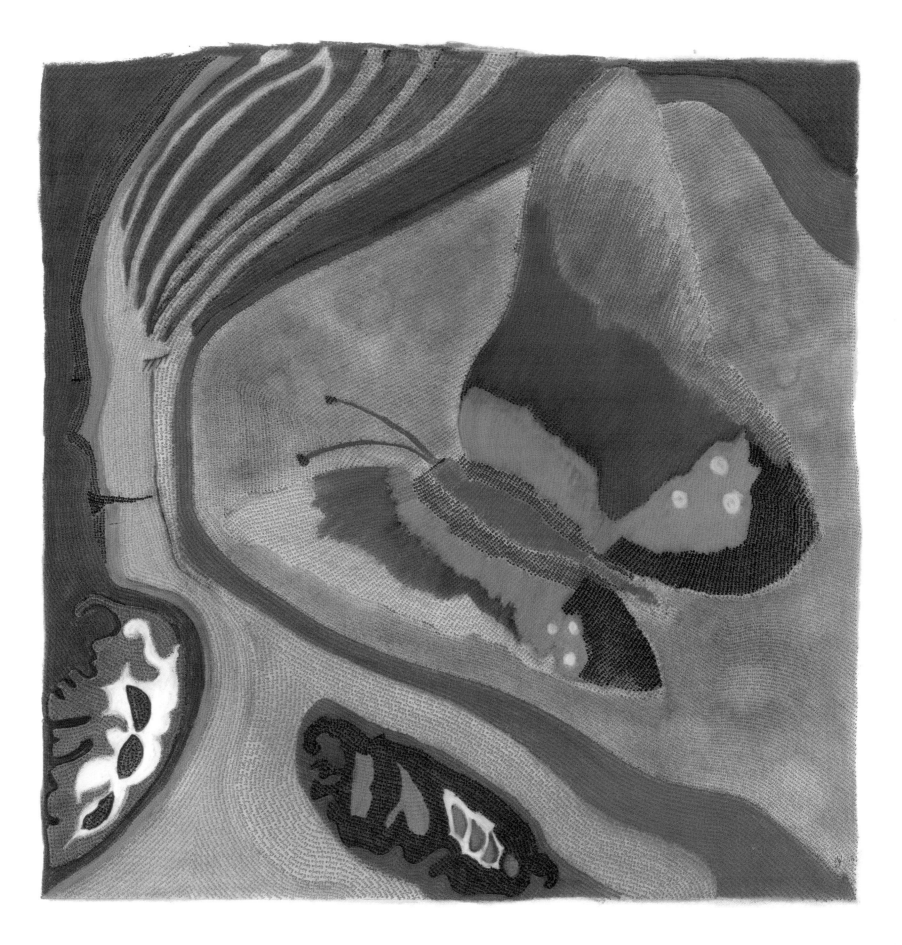

WAKING UP

I recall an example that B gave to illustrate the principle of duality. He likened our lives to a staged play in which each of us has an integral part. The plot may include many actions and many themes including love, hate, envy, greed and kindness. However, at the end of the day, after having fulfilled our roles as actors, we simply return 'home', knowing that the whole saga was just a play and that nothing was real.

In a similar manner, the ups and downs we face in life are just constructs. If we could only remain as detached as the actors, we would not be affected by the chaos all around us. In spite of this knowledge, the lethargy-inducing effects of the materialistic vibrations surround us, making it impossible to truly 'wake up'. Instead, we continue to be duped by the illusory, sensory world, which seems to be real. To be awake in this dream, to know my real self within this sensory illusion is what my heart yearned for when this painting was made. I too wanted to learn to be in this world but not of it.

SPIRITUAL BLOSSOMING

It dances today, my heart,
like a peacock it dances,
it dances.
It sports a mosaic of passions
like a peacock's tail,
It soars to the sky with delight, it quests,
Oh wildly, it dances today, my heart,
like a peacock it dances.

— Rabindranath Tagore

Peacocks are exquisite works of nature symbolising many different things according to different faiths and traditions from around the world.

For Buddhists, the open-tail signifies understanding and acceptance. The peacock in Christian tradition is associated with purity and resurrection. Greco-Roman mythology has it that the peacock was given the eyes of a hundred-eyed giant, Argus, each representing the stars as well as vision, spirituality, awakening, guidance, protection and watchfulness.

It is only when a peacock is in love that its full plumage explodes; all the colours of the rainbow shining on one body. The eye-catching sparkle one sees comes from tiny crystals embedded throughout the feathers, which bend and reflect light in curious ways to make the birds appear incredibly vibrant and enchanting. When these crystals dampen, they glisten even more, making the peacocks more attractive to potential mates. This is especially noticeable during monsoon rains as peacocks dance and cry out joyfully with the onset of their mating rituals.

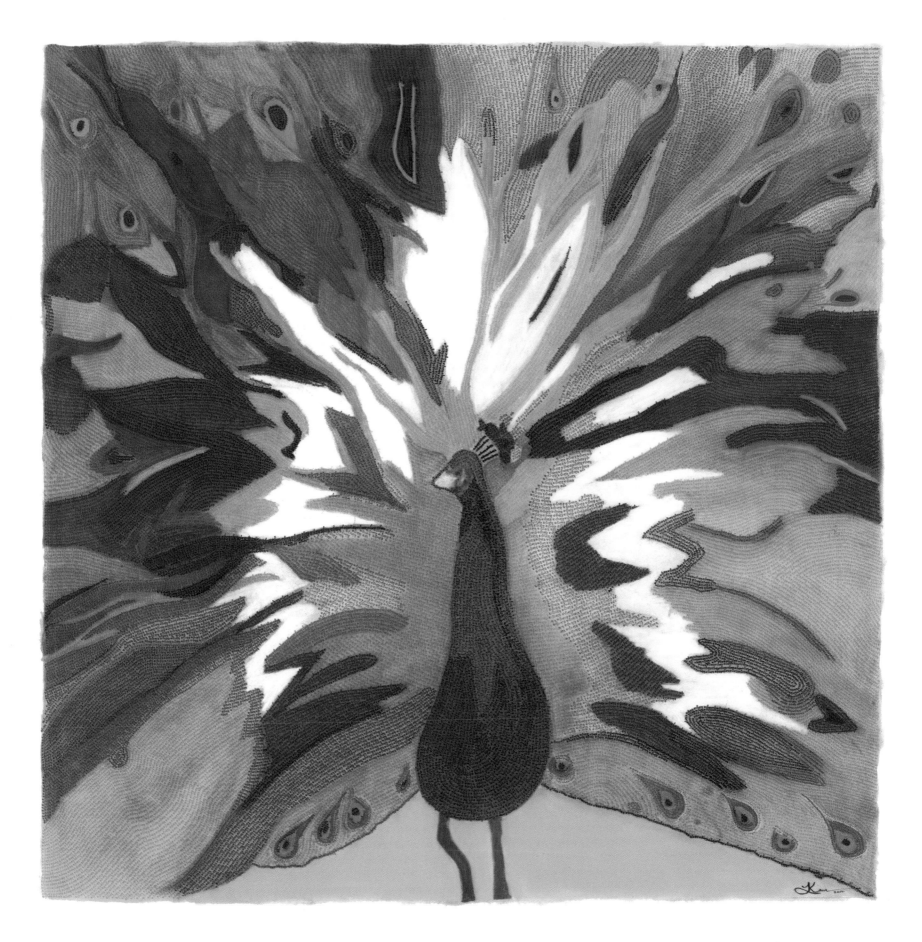

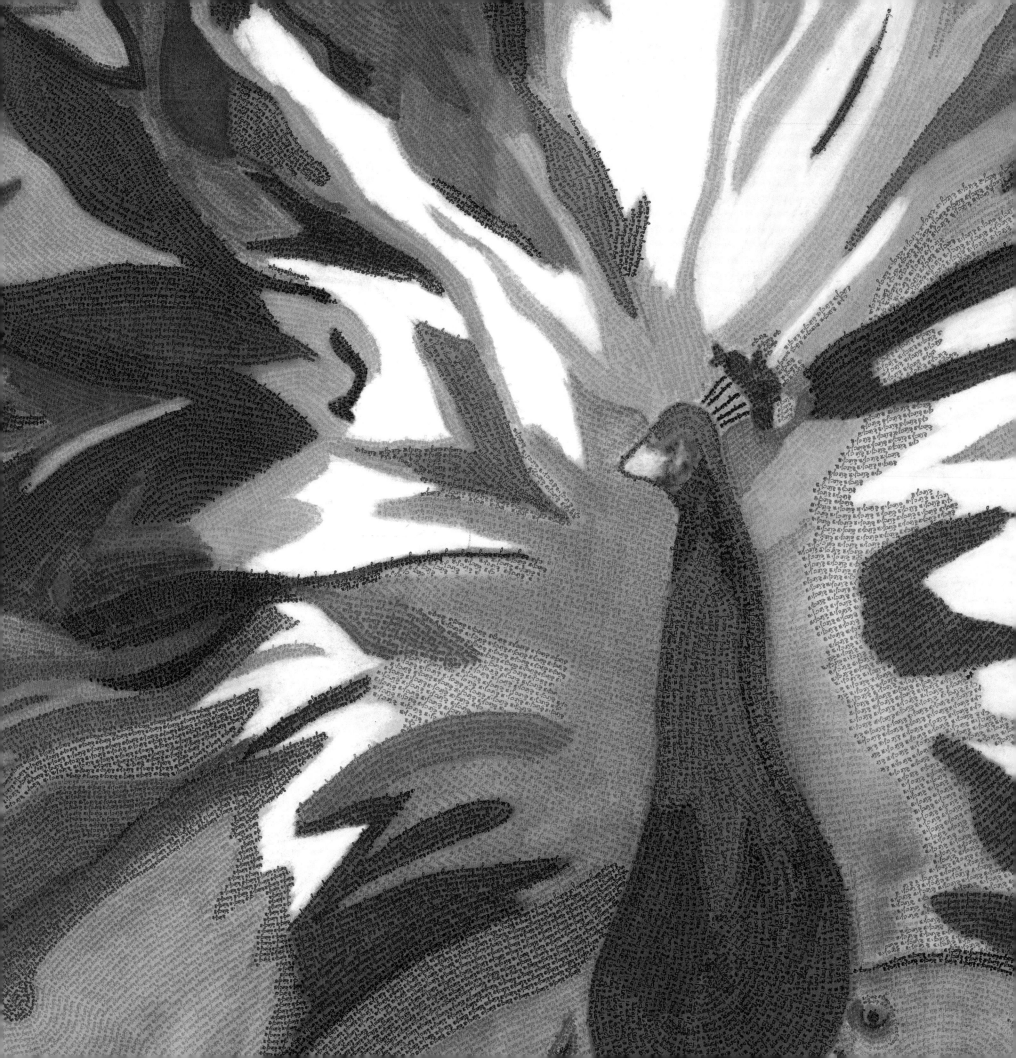

ONE'S TRUE COLOURS

Feeling encouraged with the positive responses I received after creating The Tree of Love, I started on this, my second large artwork.

The colours of the rainbow are striking in a visual sense, but how often do we stop to consider the emotional impact they have on us? How often do we consider their power to influence us and to resonate with our deeper feelings?

I felt great inner joy well up within me as I painted this beautiful peacock spreading its wings in its full glory; the image and all it represents reverberated within. I called it Spiritual Blossoming to share the feelings of how when one is in tune with the music of the universe, the spirit blossoms forth in every aspect of one's life, similar to how the plumes of a peacock fan out. Like the peacock, one cannot help but radiate joy, blossoming and bursting into one's true colours. This sensation is beautifully expressed in Sikh teachings: 'The peacock of the mind chirps when it receives the drop in its mouth with the realisation that it is Consciousness itself.'

HARMANDIR SAHIB

*The Life-Giver has fashioned
the body as the Life-Giver's temple,
O my dear beloveds;
the All-Pervasive One
continues to dwell there.*

— Guru Arjan

To understand the sacredness of our bodies as temples, it is useful to compare a temple of bricks and mortar with a temple of flesh and blood.

Temples serve a singular purpose; they are built as structures to manifest the One and thus become focal points for pilgrims imbued with love, hope and devotion. The Harmandir Sahib (popularly known in the West as the Golden Temple of Amritsar) is the most sacred place of worship for Sikhs. Its exterior has a glorious combination of gilt-copper plating on its upper storey and white marble slabs inlaid with coloured stones on the lower. The interior is even more beautifully and elegantly adorned. The central structure is surrounded by a pool of water. It remains a beacon of hope and purity, kept impeccably clean and peaceful to help pilgrims find solace.

Likewise, our own body is also a sacred place, a holy shrine of reverence that must be kept pure by means of meditation. The presence of the spirit can be felt within only when the sanctity of this holy abode is kept. Only then may we truly realise our oneness with the universal Consciousness.

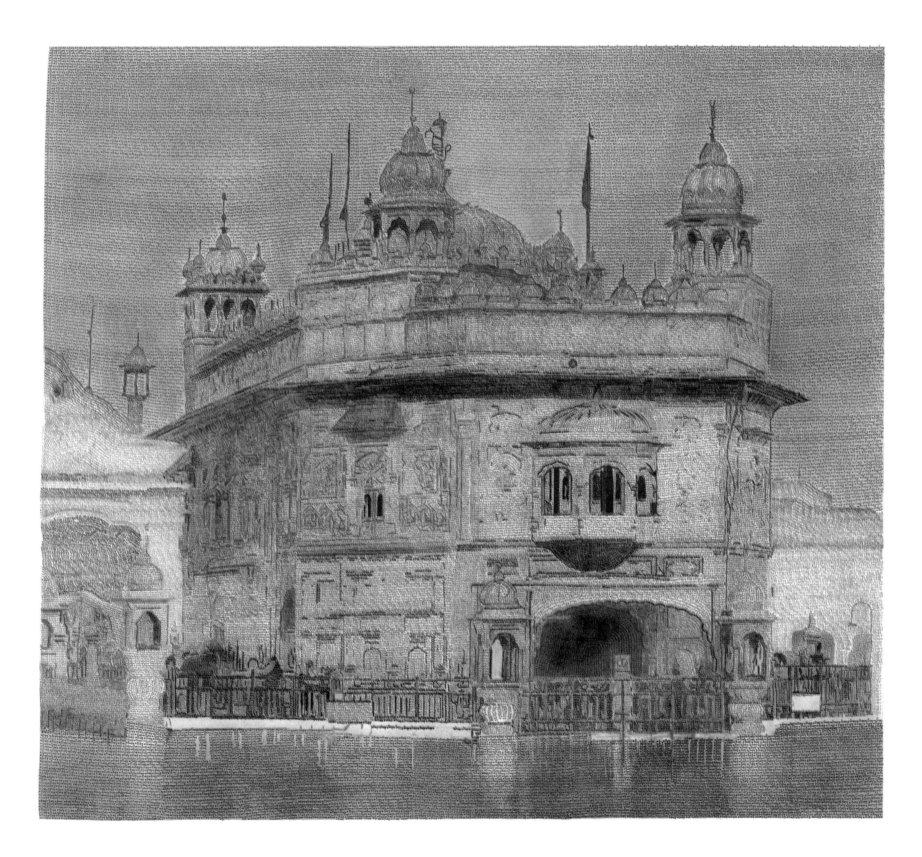

INSTRUMENT OF LOVE

My first exhibition in Montreal was held in 2013 at The Montreal Art Center in the trendy setting of Griffintown. This place is home to many artists, so I was exposed to a variety of art, while also having the opportunity to introduce mantra art to them. Simultaneously thrilling, humbling and exciting, it was also a time for reflection. Up until then, I had pursued this meditative art form only for myself so it felt strange having others gaze into what felt like my soul. It was only when I disassociated myself from the art, from claiming it as 'mine', that I was able to feel comfortable and grateful to share it with others.

When I finished this particular painting, I placed it on the mantelpiece in my home – a practice I follow with all my paintings, as it allows me to see the work from all angles to pinpoint things I can improve. After a few days, I had a distinct and almost surreal realisation – I had not produced this piece. In fact, I couldn't produce it even if I tried! I understood my role for the first time. I was like a teapot, a mere vessel to be channelled by my master, whose grace and elegance was being transmitted through me. I bow in deep reverence and gratitude to the One who poured the tea out of this teapot.

SACRED GEOMETRY I:
THE FLOWER OF LIFE

Geometry existed before creation.

— Plato

The belief that geometrical foundations underpin the creation of the cosmos is rooted in Plato's ideas. From this perspective, contemplating on the great mysteries of the universe is perceived as sacred geometry and this is reflected in the complex system of symbols and structures – involving space, time and form – that can be found in most archaic temples of all religions as well as in nature, art and architecture more generally.

The Flower of Life is one of these geometrical representations. This mandala is composed of multiple evenly-spaced, overlapping circles that are arranged to form a flower-like pattern with six-fold symmetry, similar to a hexagon. The centre of each circle is on the circumference of six surrounding circles of the same diameter.

The concentric overlapping energy circles link us with the spiralling movement of consciousness all around us. Pythagoras framed it beautifully: 'There is geometry in the humming of the strings. There is music in the spacing of the spheres.'

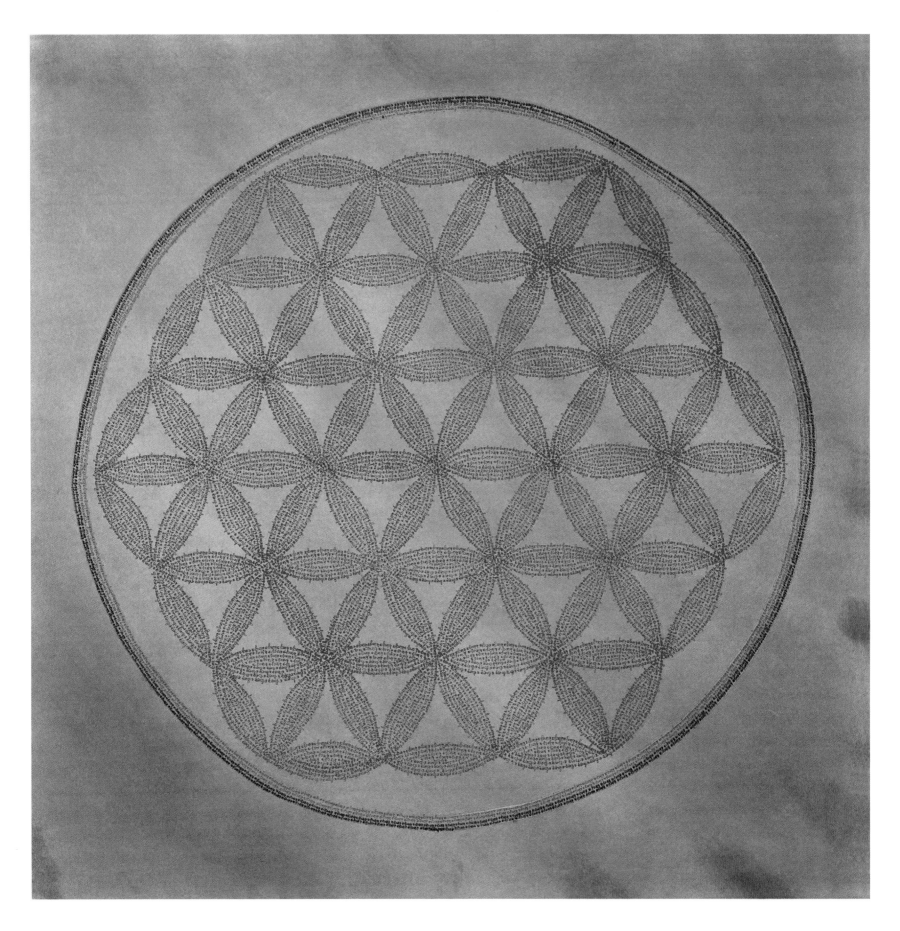

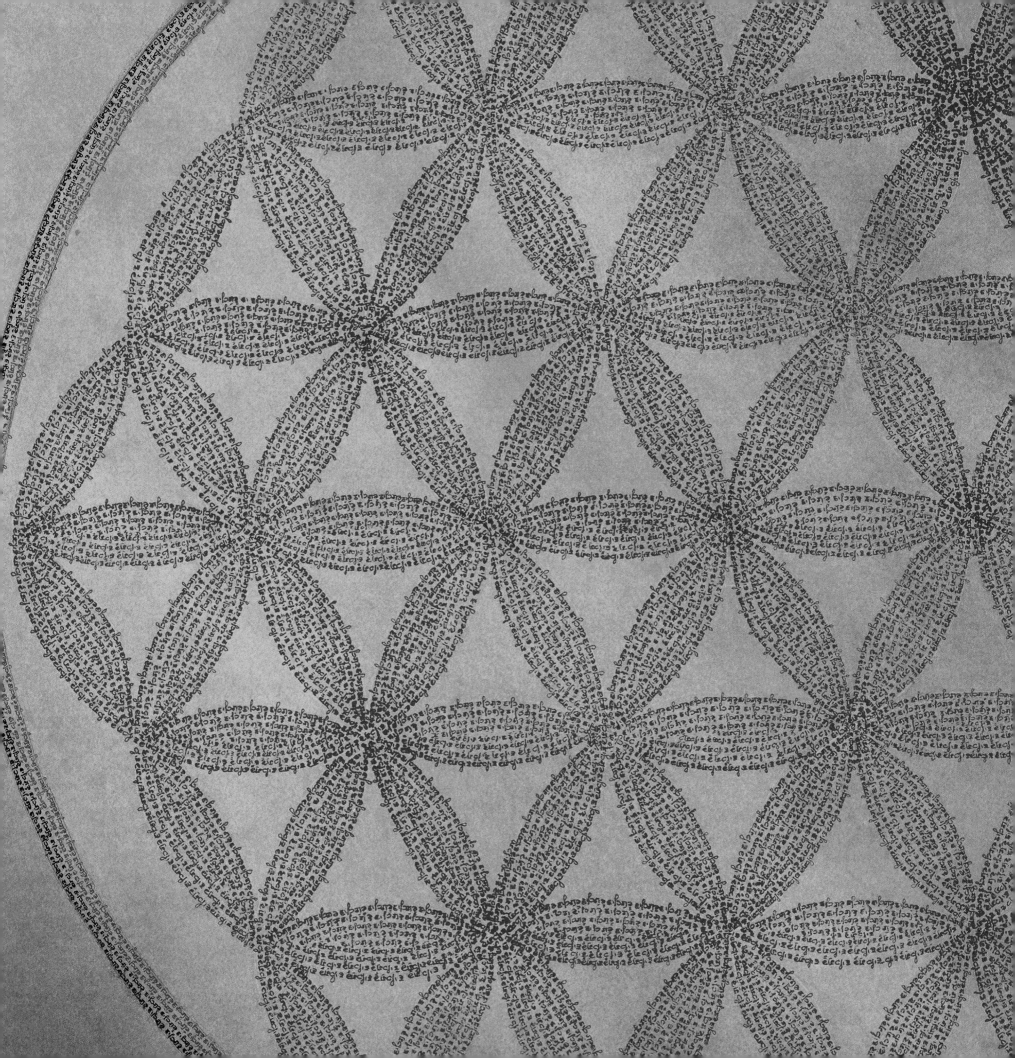

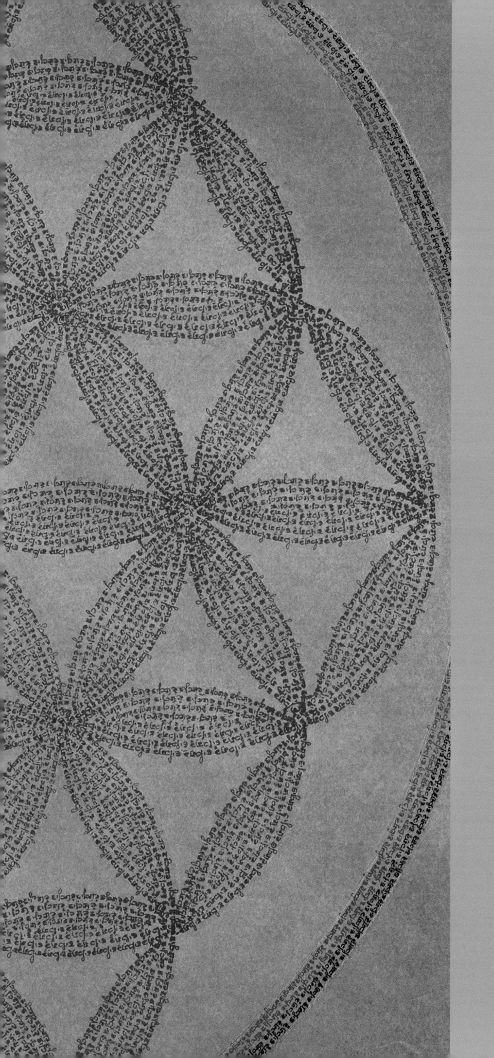

MESMERISED BY CIRCLES

I became fascinated by the concept of sacred geometry after I saw a documentary on the subject. What particularly intrigued me was how ancient temples around the world all had very similar geometrical designs at a time when there was no possibility of communication. To see the very same designs emulated in nature was astounding.

My act of creating the mandala and then writing the Waheguru mantra in The Flower of Life produced a mesmerising effect. As the pen traced around the circles, the connectedness, the oneness of the universe, seemed to come alive. When I had completed the process, I found out through further research that it was one of the many beautiful intricate patterns around the periphery of the sacred pool at the Harmandir Sahib (or the Golden Temple in Amritsar), the holiest place of pilgrimage for Sikhs. Belonging to the Sikh faith, I related to it immediately and was further intrigued by its origins. It led me to my next painting, The Tree of Life.

SACRED GEOMETRY II:
THE TREE OF LIFE

Learn how to see.
Realise that everything connects
to everything else.

— Leonardo da Vinci

The Tree of Life comes from the centres of the spheres of The Flower of Life. It is a modern symbol of mystical Kabbalah used in the teachings of Judaism to represent a pathway to the One.

The ten individual but interconnected spheres on the tree are said to be channels of divine energy on the body and are collectively referred to as the *sefirot* in Hebrew. By learning more about these individual states of energy, one is able to perceive how each one is relative to our human experience and not something solely 'outside of you' – they are both internal and external and relate to the physical and metaphysical worlds.

The designations and numerals of the ten sefirot are listed in sequence below:

1. Divine Will (The Crown)
2. Wisdom
3. Understanding / Knowledge
4. Kindness
5. Strength
6. Beauty
7. Eternity
8. Glory
9. Foundation
10. Kingdom

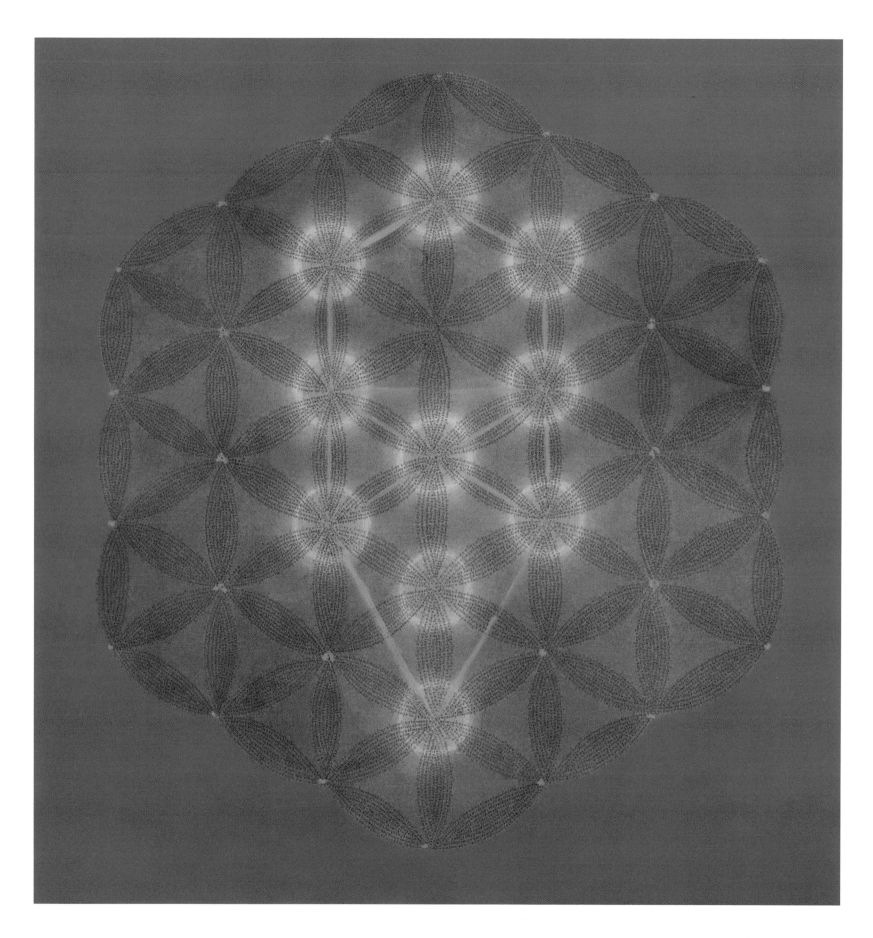

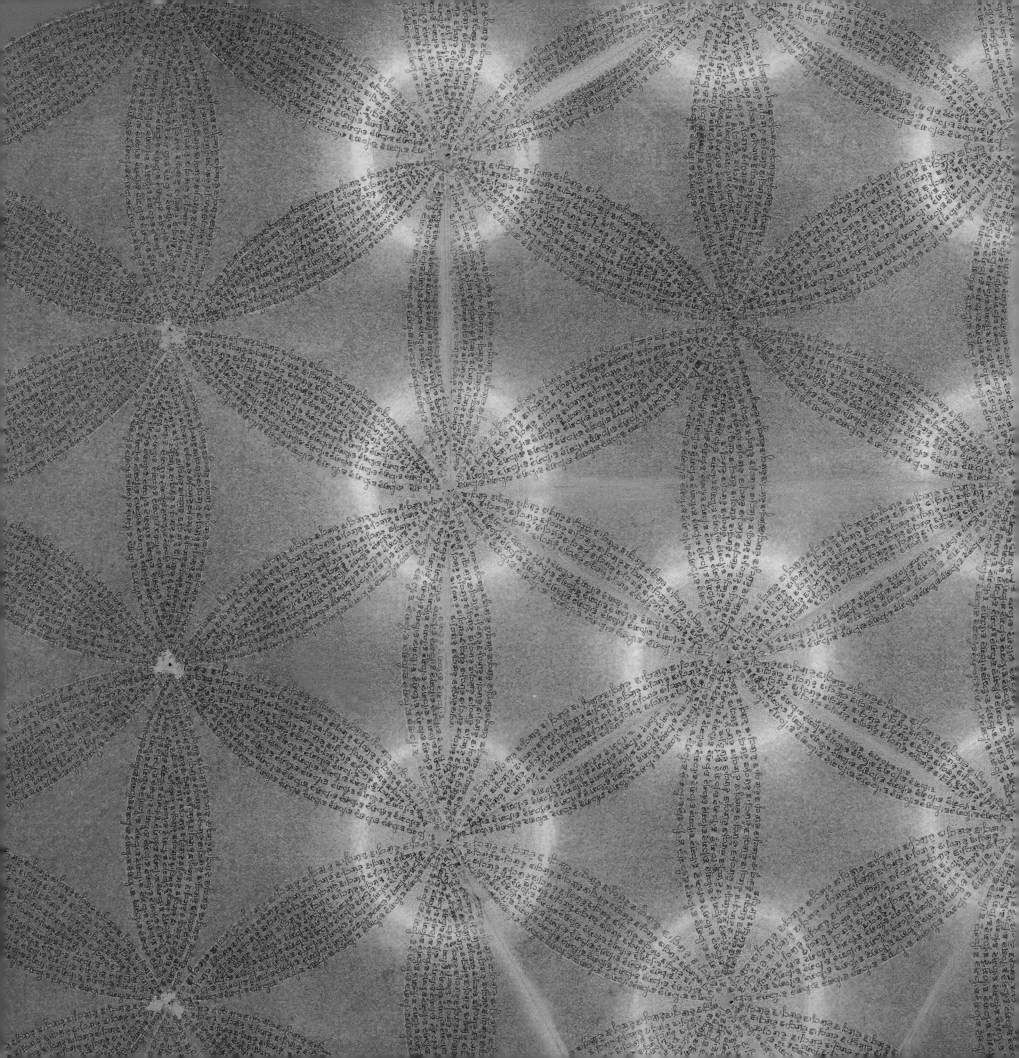

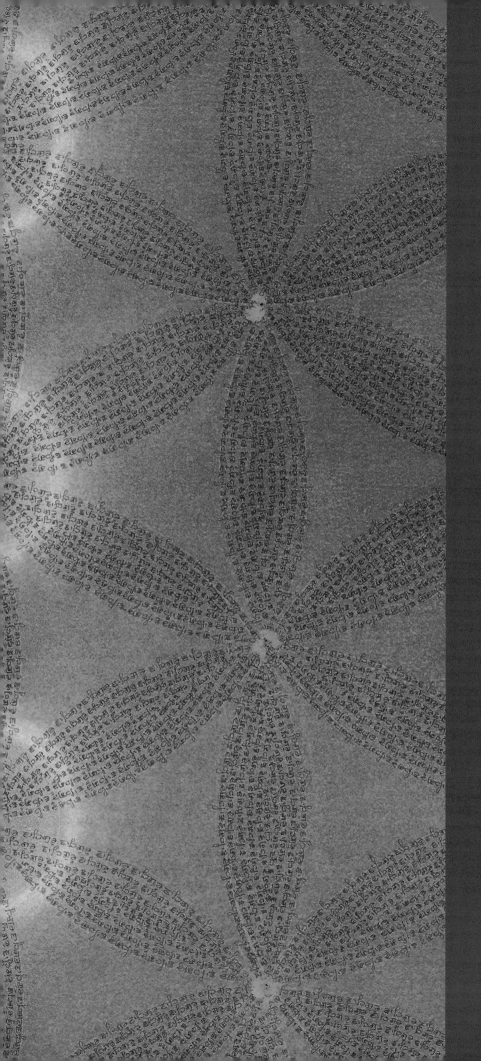

TOUCHING SOULS

I have always had an interest in the different paths that people choose to discover their inner spirituality. Naturally then, when I discovered that The Flower of Life led to The Tree of Life, I wanted to learn more about the sefirot and how each one teaches us the truth about ourselves and our place in the world. The very act of contemplating and creating this artwork aroused wonderful feelings, but intellectually I could not grasp the subtleties. For that, I would need a master to guide me.

I made this painting as a follow-up to The Flower of Life for a 2014 exhibition held at the Beaumont Studios in downtown Vancouver. I recall that on the last day of the show the art director, who was helping to curate the next artist's work, walked in and bought it, confessing he felt deeply drawn to The Tree of Life. This happens at least once in each exhibition; someone will be profoundly affected by a particular piece of mantra art, sharing with me how it has touched their soul.

Through these interactions, I am repeatedly and pleasantly made aware of the hand of the Divine in the entire process.

THE MASTER

The Word is the Guru,
and the Guru is the Word.
Within the Word is contained
the ambrosial nectar of immortality.

— Guru Ram Das

Spiritual unfoldment comes not from merely offering reverence to holy scriptures but through an intuitive understanding of the messages embodied within their passages. This painting of a holy book was triggered by an excerpt from an essay entitled *Wordless Word* by Khoji ('The Seeker'), a pen name used by my spiritual mentor. He explained that 'enlightenment comes only to those who grasp the true essence of the Eternal Divine Song'. This 'song' was what he regarded as the Wordless Word. It is the conscious realisation of the presence of the all-knowing, all-powerful, all-benevolent, ever-present energy flowing within and without, beyond the illusory senses, which leads to the fundamental union with the One. He would say this 'song' cannot be taught, it has to be caught for it is 'beyond learning and teaching; beyond understanding and making it understood; beyond the reach of the intellect; beyond rites and ritual; beyond the sphere of religion; beyond the debate of philosophy'.

So, it is only when the focus of the mind turns inward though daily contemplation and meditation that our very existence becomes sublime. When the spiritual consciousness awakens, only then can the true presence of the Master be known. Thus, it is not the physical aspects of the book that is the Guru or the Teacher, but the vibrating Wordless Word embodied as the message – there lies the True Master.

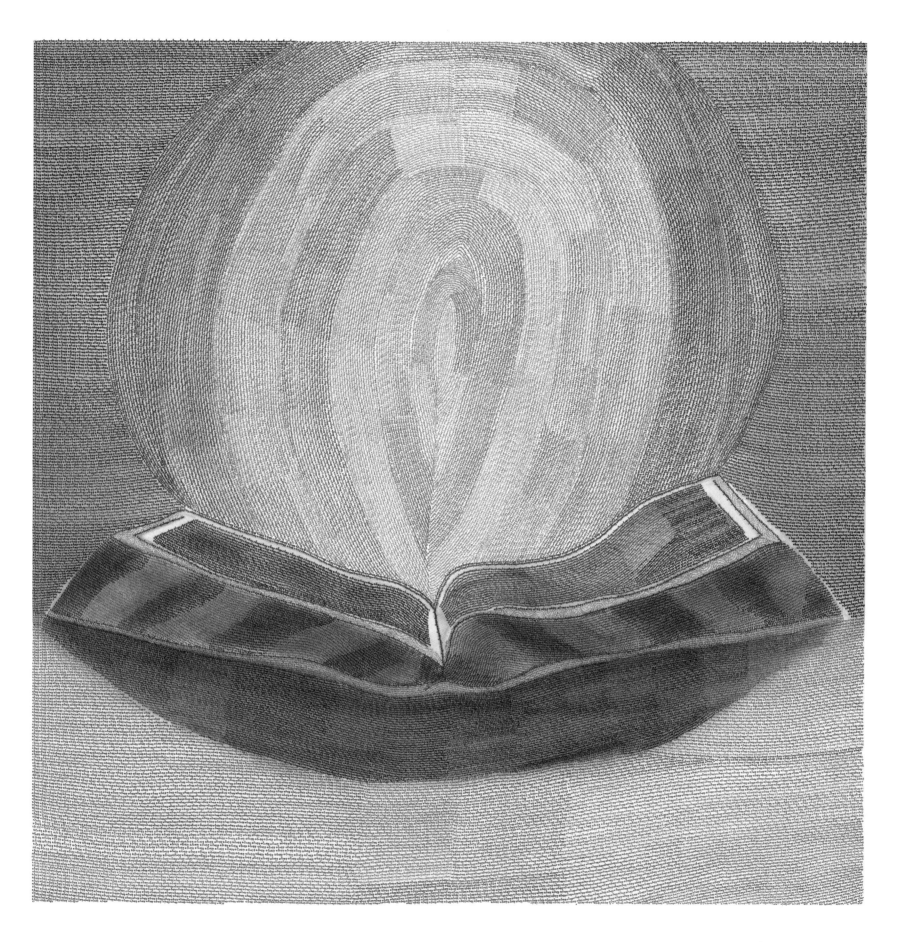

SEEING THE UNSEEN

What was initially the mere mechanical writing of the Waheguru mantra gradually turned into an instrument of contemplation, of realising the deeper meanings of my own divine inheritance as a child of the One. It seemed to be a way to release the immeasurable treasure lying within, as explained in the next painting, The Imprisoned Splendour. This piece was inspired as a result of this essence that was slowly but surely revealing itself to me. Each time I came away from a work in progress I was left in complete awe.

For decades I had assiduously read, written down and sang the inspiring words contained in holy scriptures. But now I could see that my intentions had been only about me, myself and I – ego-driven, personal and hollow. Always needing, wanting, desiring a person, a condition or a circumstance, I was finally learning intuitively to let go of all these external restraints. The past and the future were no longer a concern and source of remorse and anxiety. Like the fish swimming in the ocean in search of that very same ocean, the message right there before me had been unseen – until now.

THE IMPRISONED SPLENDOUR

All is within the home of the self;
there is nothing beyond.
One who searches outside
is deluded by doubt.

— Guru Arjan

Our yearning to know the One is an intrinsic, innate desire that compels us to follow religions, go on pilgrimages and pray. In our delusion we try our hardest to 'please' the Infinite, who we believe sits in judgement weighing our virtues and vices – constructs that are brought about by our personal perceptions of space and time.

The union that we seek, one that will bring us inner peace love and happiness, can only be found by realising that its presence lies within us. There is no point in charging around, looking for it in external stimuli. As Robert Browning observed in his poem *Paracelsus*, 'Truth is within ourselves. We must open out a way for the imprisoned splendor to escape'.

It is only by consciously recognising our connection with the One that we can free the glorious splendour within, allowing it to unfold so that we can begin to live to our true potential. Saints and other enlightened individuals are examples of such realised beings who become conduits for the flow of love and peace into the world.

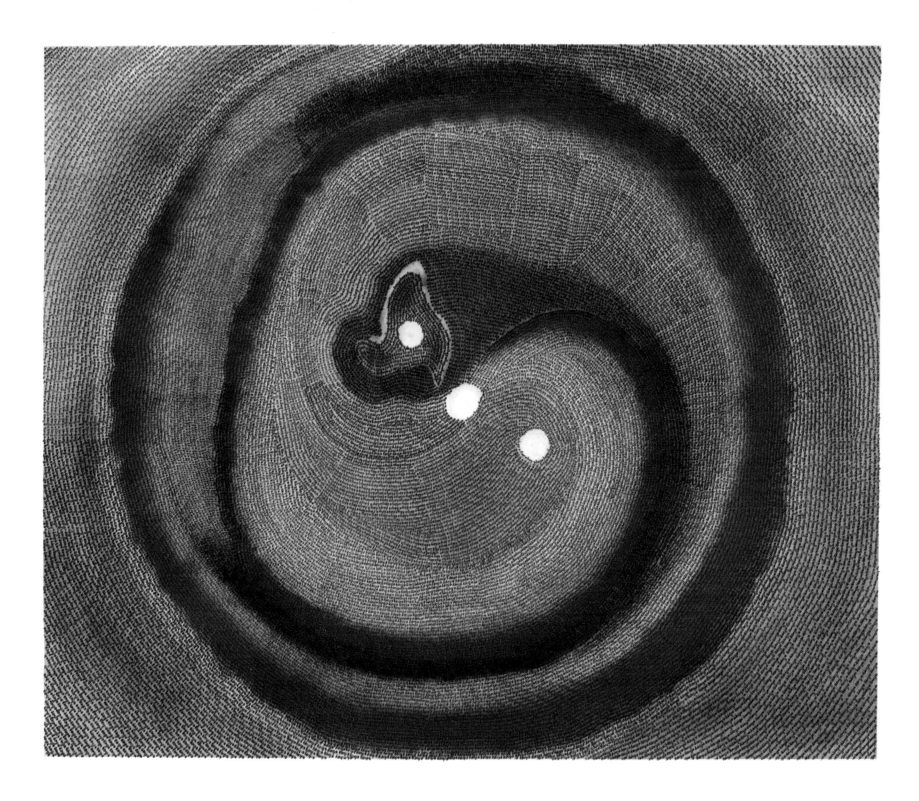

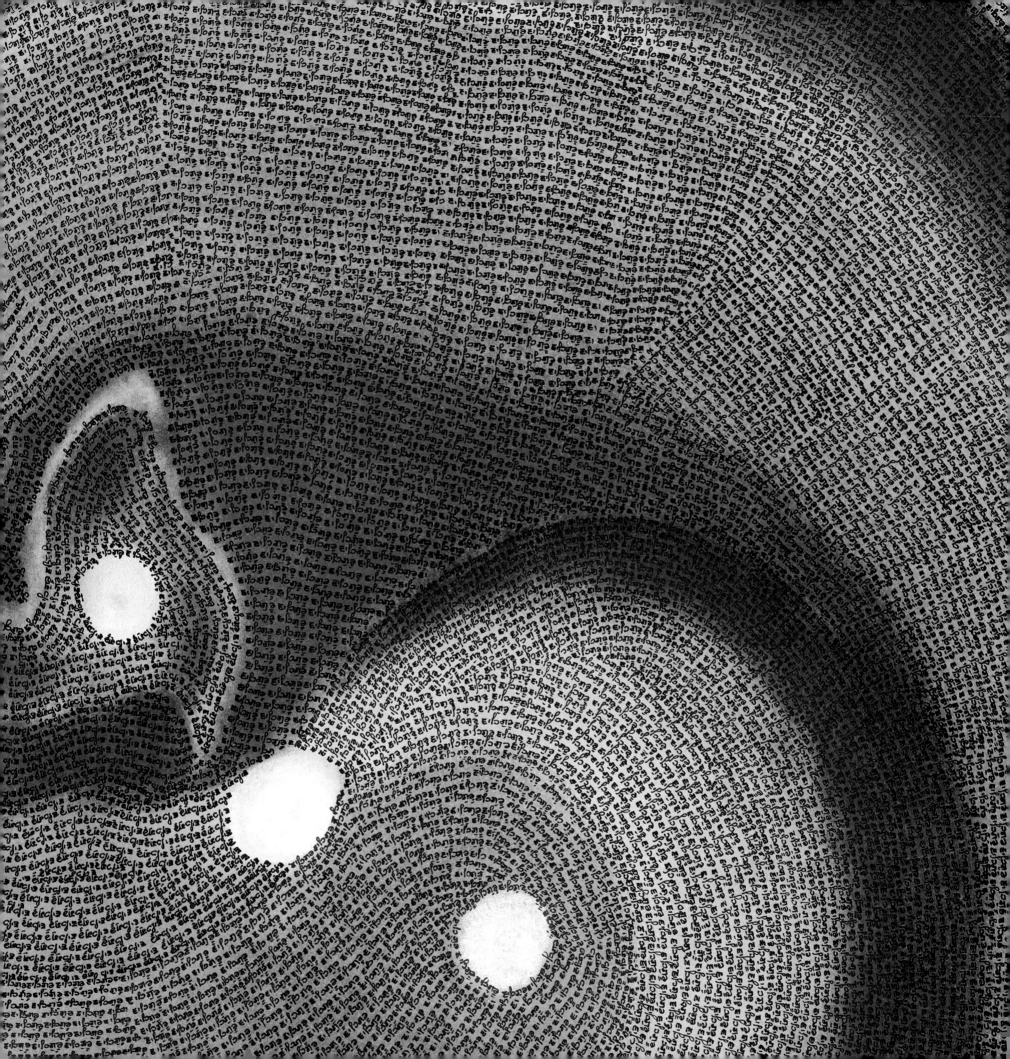

BECOMING THE MIRROR

Being a spiritual singer, I had both read and sang about an inner, hidden treasure for years. But, for some reason, when I read Browning's poem, it left a profound effect on me; the words 'imprisoned splendour' resonated strongly within. It dawned on me that if the 'splendour' lies trapped within, our efforts to find it elsewhere – whether in a place, from another person or in a particular condition – are futile.

We carry and embody our consciousness wherever we go and, thus, our present lives project our inner feelings. Through the flows of this very consciousness, we attract whatever has been realised in it. If it is love, peace and gratitude that has been cultivated, then that is what we manifest. Similarly, if we look out at the world from within our limitations and fears, we create more of the same. In this way, our consciousness functions as a magnet.

In this painting, the three white dots each signify the attributes of consciousness that have to be cultivated and realised – omnipresence, omniscience and omnipotence. Inscribing the Waheguru mantra in this painting had a thrilling effect on me, similar to the one when I had created the mandalas. B had said that the purpose of one's life is to become a mirror for the reflection of divinity and an agency for dispensation of sublime attributes of kindness, compassion, energy, joy, bliss and love. I finally understood intuitively what he meant.

EK ONKAR

The One that pervades the universe
also dwells in the body;
whoever seeks It, finds It there.

— Bhagat Pipa

This symbol communicates the cornerstone of Sikh philosophy – the belief in both the oneness of spirit and of humanity. There is only one Divine Reality, one Creator that is manifest in the entire universe, and It is the only constant, the Eternal Truth.

One-in-All and the All-in-One – the creator and creation are one entity. This understanding urges one to realise that we are all bound to the Creator, intertwined in such a way that we are inseparable.

Ek means 'one', *on* is 'everything' and *kar* stands for 'creator'. Thus, Ek Onkar translates as the One that reveals itself ceaselessly throughout all creation in diverse forms, features and colours, but remains One. The Creator is immanent in creation; transcendent, at once singular and plural. 'The Creation is in the Creator,' praises Bhagat Kabir, 'and the Creator is in the Creation, totally pervading and permeating all places.'

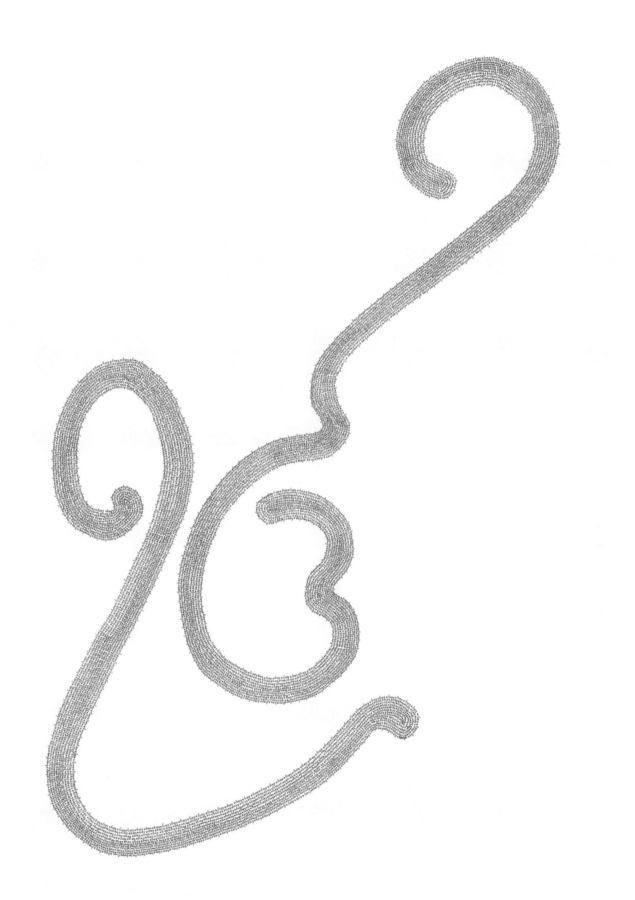

AN ASTOUNDING TRUTH

The concept of oneness became especially close to my heart ever since I started writing the Waheguru mantra to illustrate my feelings that energy or divine vibrations exists within everything. So, when I was invited in 2016 to give a TEDx Talk in Montreal, it was little surprise that I chose to talk about Oneness. The preparation and then the actual delivery of the talk was a particularly amazing and utterly fulfilling experience. I did not only want to 'talk' about oneness, but to 'feel' it within, and so I put my heart and soul into it. I think it was this intense feeling and realisation that gave rise to a standing ovation – not the messenger but the message. Inherent in all of us lies the understanding of this oneness speaking to us incessantly; it seems like the audience that day chose to hear it.

One of my favourite authors, Ralph Waldo Emerson, believed that all creation is one and advocated a simple life lived in harmony with nature and with others. In his poem *Nature*, he writes: 'The currents of the Universal Being circulate through me; I am part or parcel of God'. As the veils of separation gradually lift, we discover our own divinity. The greatest journey takes us back to the simple and yet astounding truth of our oneness.

WARRIOR SAINT

Tigers, hawks, falcons and eagles –
the One could make them eat grass.

— Guru Nanak

One of the many titles bestowed upon Guru Gobind Singh, the tenth Sikh spiritual master, was '*Baajawala*' or 'Keeper of Hawks'. The Guru's well-trained hawks played a role in infusing his Sikh warriors with worth and valour. In battle, these powerful birds of prey were employed to intercept the messenger pigeons used to relay messages between his adversary's battalions. The pigeons, however, were never harmed. The hawk's fearlessness, sharp vision, intense focus combined with stillness and wisdom beckoned all to become such warrior saints. The deep concentration of the hawk was used to awaken its spirit, teaching it to fly and soar above all obstacles as the hawk pursued its hunt.

The hawk was a constant reminder for the Guru's Khalsa, the collective name for his initiated Sikhs, to stay aware and alert — not only for external threats but also from internal ones – in order to be victorious in all facets of life.

Just being a warrior was not enough — equally important was the cause behind the fight, to help the downtrodden and to embrace the spiritual discipline set by the Guru. The devoted Khalsa knew that his mere touch and presence could turn the meek into the mighty.

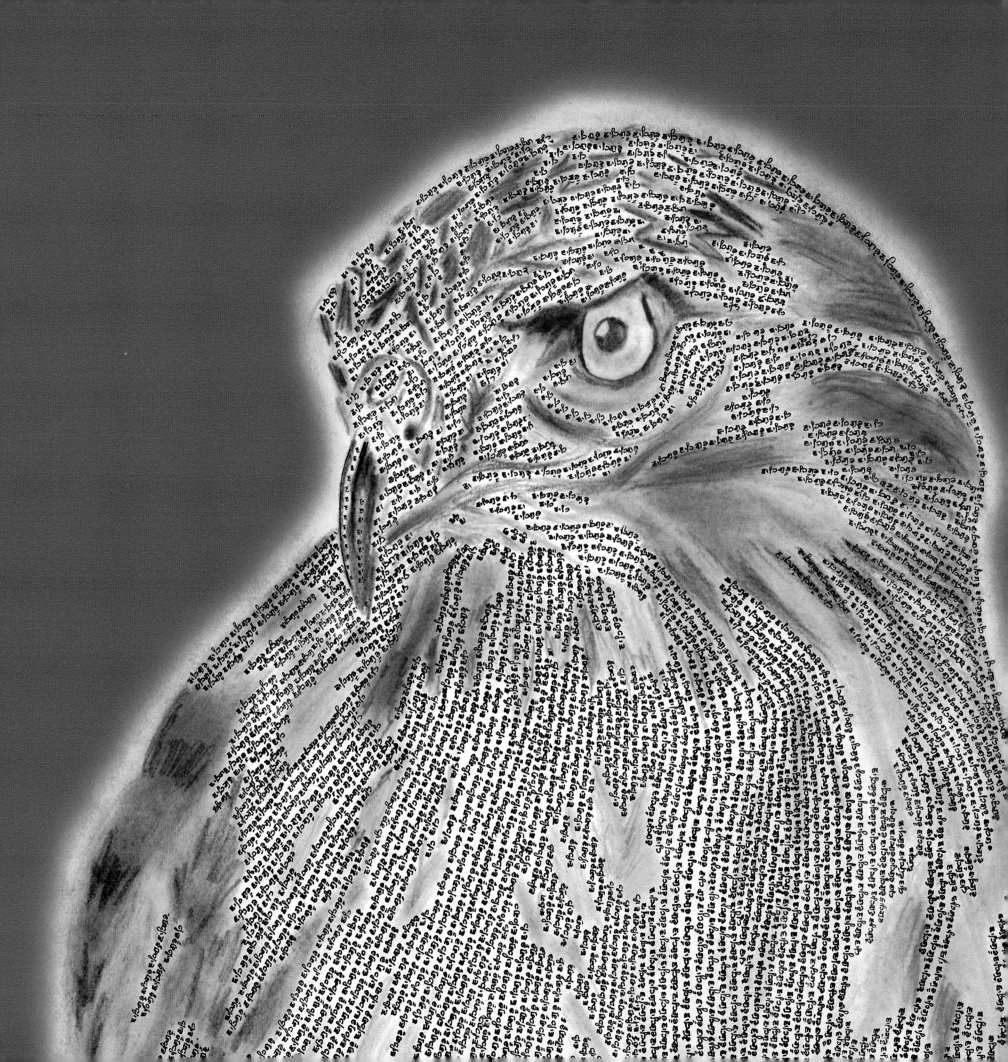

INVINCIBLE SPIRIT

Inspired by the Guru and his Khalsa, I painted Warrior Saint as a hawk imbued with an autonomous state of mind and spirit. The fearless spiritual warrior recognises that the battle is to overcome their so-called adversaries – pain, separation, ill health and other inner foes. Each make a person believe they are independent from the Creator, thus bringing about the wounds´that cause them to suffer. These ego-driven, false beliefs are regarded by the victorious spirit as hypnotisms of the materialistic world that make one believe in duality – in other words, omnipresence is negated. Undaunted, the spirit of the warrior saint remains grounded in the Eternal Truth to discover its immortality.

This painting was a constant reminder for myself to be such a warrior – one who is not only awake and aware of all illusory foes within, but who knows how to tackle them by realising and acknowledging the omnipresence of the Spirit.

THE MAZE

I speak the Truth, all should listen;
only those who Love can realise the Master.

— Guru Gobind Singh

A maze is a network of multiple meandering paths in which the 'seeker' chooses a way that either leads them to a dead-end or to freedom. Religion – which is derived from the Latin word meaning to re-unite or connect again with one's source – can be seen as a path or road that has both the potential to take the seeker to enlightenment or to become entangled and lost on the way, just like in a maze.

Regardless of what religious path one takes, it should theoretically lead to the ultimate realisation that all is One. The Creator is ever-present, all-knowing, all-powerful and not a separate entity from the seeker. When the seeker recognises their divine heritage, the search can finally stop.

Transcending the limits of the worldly consciousness and entering the subtle state of divine consciousness, the seeker also realises that the religion itself was merely a tool, a means to an end, a ladder or path leading towards the destination but not the destination itself.

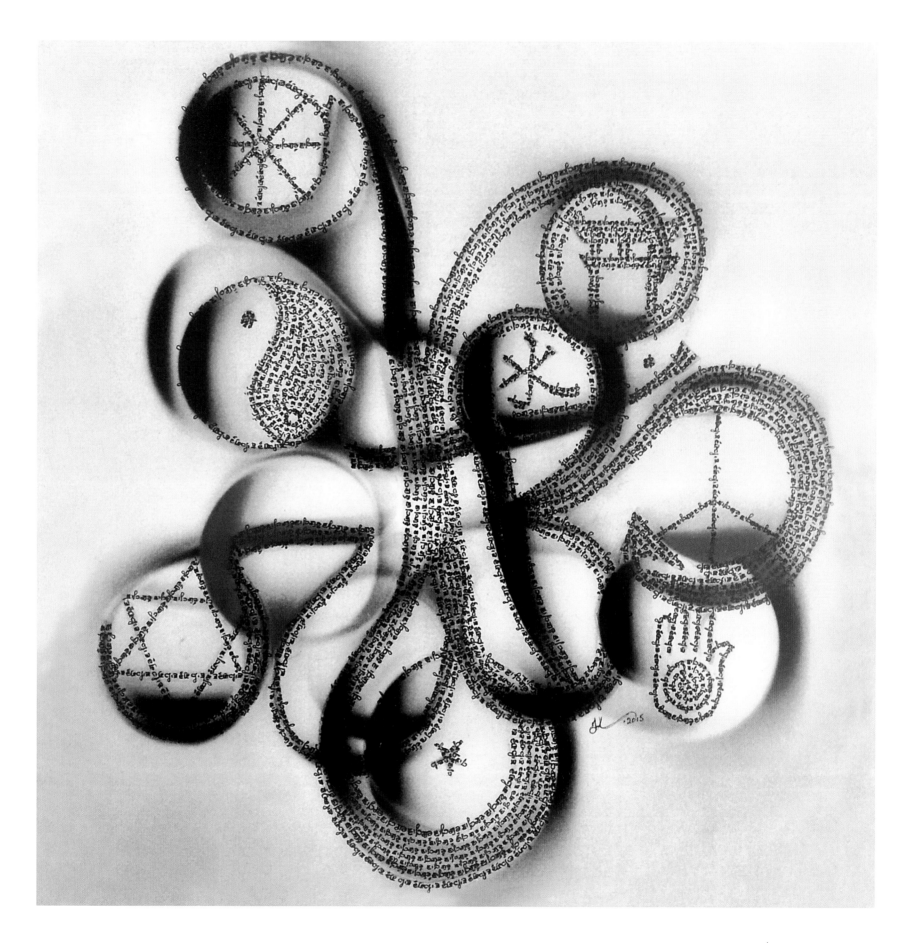

GRAINS OF SAND

The Maze was inspired with a conviction that all religions are simply different paths that take the traveller on the same journey. The path one follows does not matter. As long as it is navigated sincerely with loving devotion, it will eventually achieve the same desired result – the realisation that we are all one as we merge with the Divine.

The Maze shows 12 symbols of some of the prominent religious paths. The same mantra written in each symbol, regardless of what the mantra may be for that particular religion is a testimonial or a representation to universality. As a scientist and an artist, I believe that we are all interconnected despite all the intricacies that are unique to us all, such as how we think, act, dress, eat and speak. Oneness comes from an awareness that, despite each one of us representing a mere grain of sand, we are simultaneously all united to form the whole desert. Separate, yet not separate.

MY MASTER'S TOUCH

As the tuned string in the singer's fingers
In thy hand, I quiver with sounds
of thy heart, O' beauteous lover!
And I am silent when thou
dost lay me down, removing thy subtle,
sweet touch;
The magic miracle lives in thy hands,
by the merest touch the soul revives,
Pray do not part me from thy bosom,
from this music of union.

— Professor Puran Singh

The word 'master' is used interchangeably to mean teacher, guru, mentor or an enlightened soul who can provide guidance for a seeker. When such an entity appears in one's life, a deep, intense bond develops between the disciple and the master; a covenant of eternal, unconditional divine love.

Guru Gobind Singh had such a bond with his famed blue-coloured horse, Neela ('Blue'). At the time of the Guru's cremation, an extraordinary event occurred – it is said he rode into his hut-like funeral pyre on his horse. No remains were ever found.

Contemplating on this loving bond gave me shivers and goose bumps. How does one even begin to thank a master? Is it even possible? Even when every pore on one's body oozes gratitude, love and reverence, it still cannot be enough.

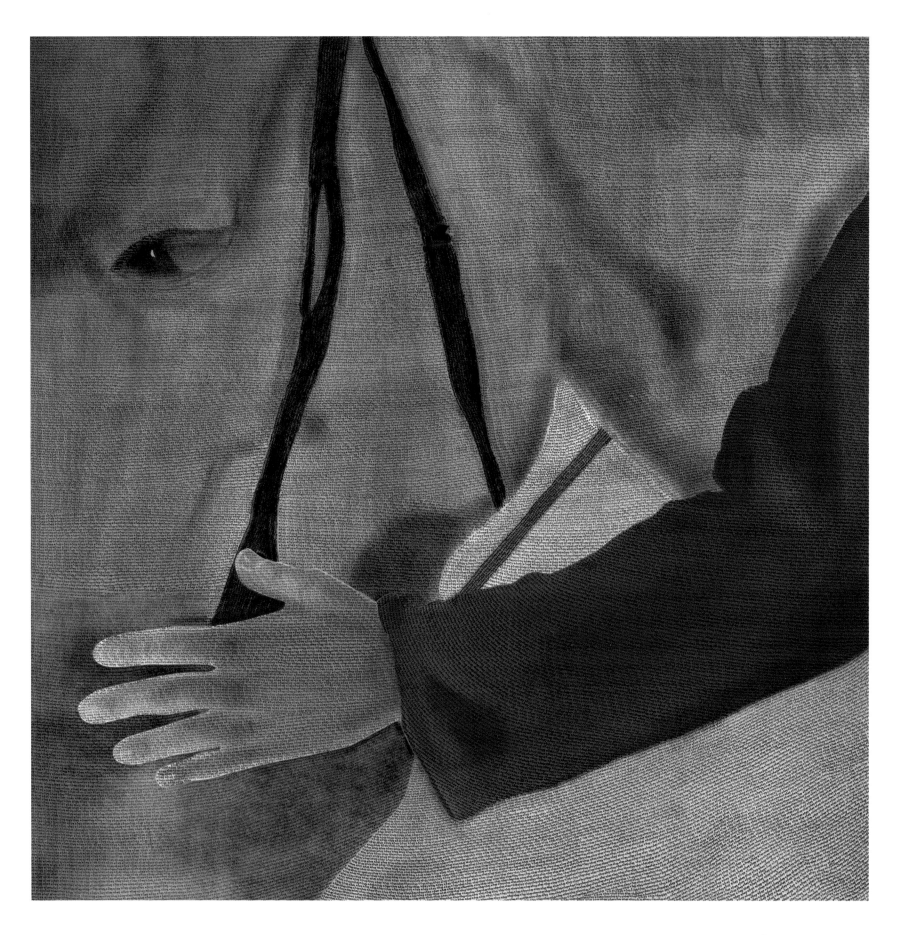

A HORSE'S PERSPECTIVE

One February morning, I was touched by a poem written by Lynda Nelson in her book, *My Master's Touch*. Written from a horse's perspective, Nelson explores the relationship between the horse and its master. What's particularly poignant is how the horse hungers and waits each day for his master's affectionate touch. I sat in blessed remembrance of my master and all the wealth of spiritual teachings he had imparted to all. Reflecting thus somehow transported me to think of how Neela must have felt when his master, Guru Gobind Singh, came to him, stroked him and rode him. Horses are regarded as highly sentient beings, and I could not help but wonder how blessed Neela must have felt to serve such a grand master! How he must have quivered at his touch. These thoughts prompted me to create this painting.

SEVENFOLD LABYRINTH

He who looks into himself,
as into an immense universe,
and carries Milky Ways in himself,
knows also how irregular
all Milky Ways are;
they lead into the very chaos
and labyrinth of existence.

— Friedrich Nietzsche

This complex and circuitous path that leads from a beginning point to a centre is an intriguing ancient Celtic design that can serve as a spiritual tool for meditation and prayer. The metaphorical symbolism of the labyrinth as a pathway or a spiritual track can aid one to reflect on the complexities of life and its greater mysteries.

This seven-layered maze originated during Palaeolithic times and can be seen at various locations around the world. By combining the imagery of the circle and the spiral into an oblique but meaningful path, it mimics life's journey — the separation from our divine nature and the return to wholeness. Each layer is said to correspond to one of the seven *chakras* or energy focal points in the body. Finding one's way out from the centre represents the soul's journey through the seven sheaves of delusion until it reaches the spiritual level where it can become one with the universe.

Although the path makes one meander back and forth, sometimes forcing one to flip 180 degrees, the change helps one's awareness by inducing an altered state of consciousness. The whole objective being to become mindful, peaceful and quiet inside so that the still silent voice within can be heard.

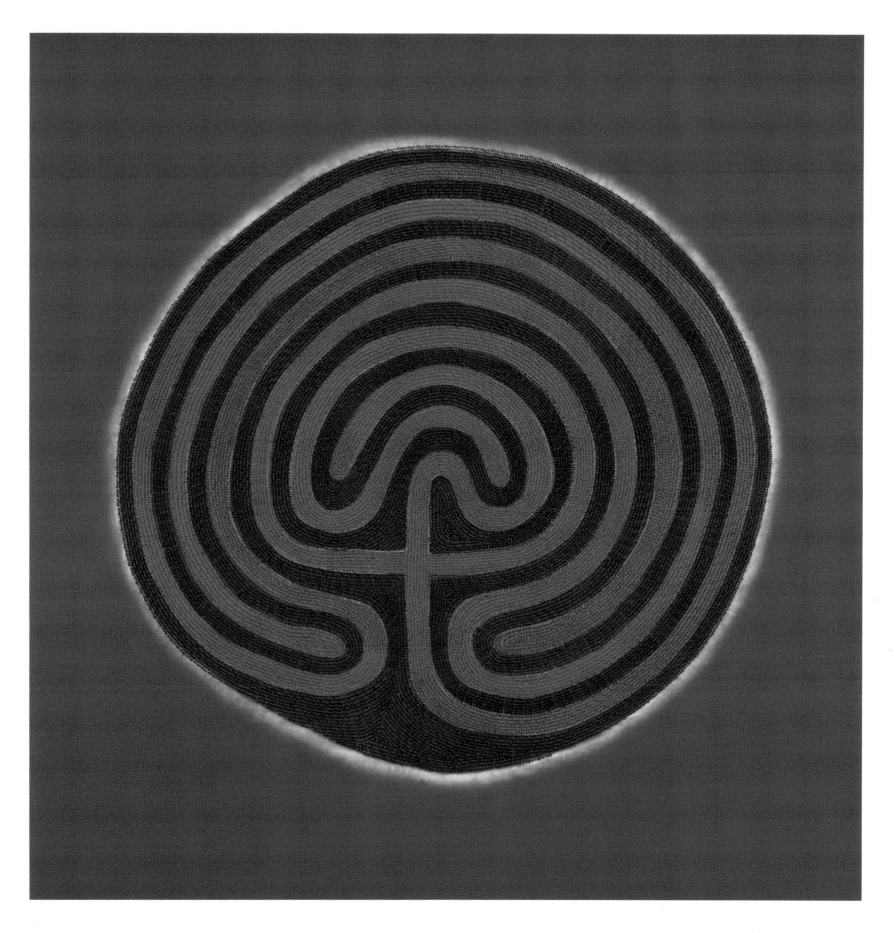

NEAR YET FAR

My walk uphill to McGill University's education department took me past various student service buildings. A sign in the window of one of them seemed to call out to me – an invitation for students to walk in a labyrinth as a form of meditation to deal with stress. Having never experienced such a thing before, I was intrigued by the prospect. One day, I decided to inquire further and ended up walking the labyrinth. It was drawn out on a cloth and spread out across the floor of a large room.

The goal was to follow the meandering paths to the centre. The traveller was constantly teased; when the centre seemed just within reach, without warning, you were carried to the outer edges. At other times, walkers, who seemed far away, would suddenly cross your path. Performing this exercise reminded me of the many times I thought that I had reached a certain understanding in my own life only to find that it was an illusion. The experience led me to realise that even misunderstandings played a role in guiding me inwards, towards my centre at all times.

As with anything that captures my attention, I ended up researching labyrinths. This interest, combined with the fact that the labyrinth's circular design mimics a mandala and incorporates sacred geometry of my previous paintings, compelled me to make this painting. The process of drawing and painting the labyrinth, and then later writing in all the Waheguru mantra, was an enthralling meditative experience. It not only added to the mandala collection, but also opened up another way to connect with the universe.

DIVINE ROMANCE

Like the flower which cannot but spread
its fragrance, even when crushed,
anyone afflicted with this joyful infection,
this romance, is on fire with that love,
and cannot help but spread it silently,
secretly and spontaneously to all,
regardless of class, colour or religion.

— Khoji

Divine romance or love is beyond the comprehension and grasp of our limited intellect. We are unaware that not only are we like the shining sun, a boundless desert, or a fathomless ocean, but we are also like a bottomless treasure chest of sacred secrets just waiting to be discovered.

Divine romance can be visualised as an infinite number of golden threads of energy or vibrations – they emanate from all things, are everywhere, and embrace and encompass everything spontaneously. Most religious scriptures point to this Eternal Truth: our love for God is a universal impulse deeply encoded within us all. I refer to this as the spirit of Oneness that can only be felt intuitively and cannot be learnt. When a seeker becomes aware of this glorious Oneness and is filled with love, he or she moves along the pathways of life with a pure, radiant heart, singing the song of the beloved and spreading the sunshine of divine bliss, joy and love, all around. Such a romance requires no human-made conventions, religions, dogmas or philosophies.

As the sun shines upon all, divine romance does not seek a particular object to express itself but becomes a part of us and flows constantly, unconditionally and requires neither our acceptance nor gratitude for this outpouring. It is pure grace, regardless of vice and virtue; the Infinite's glorious manifestation of omnipresent love cannot be taught but only felt intuitively by lovers.

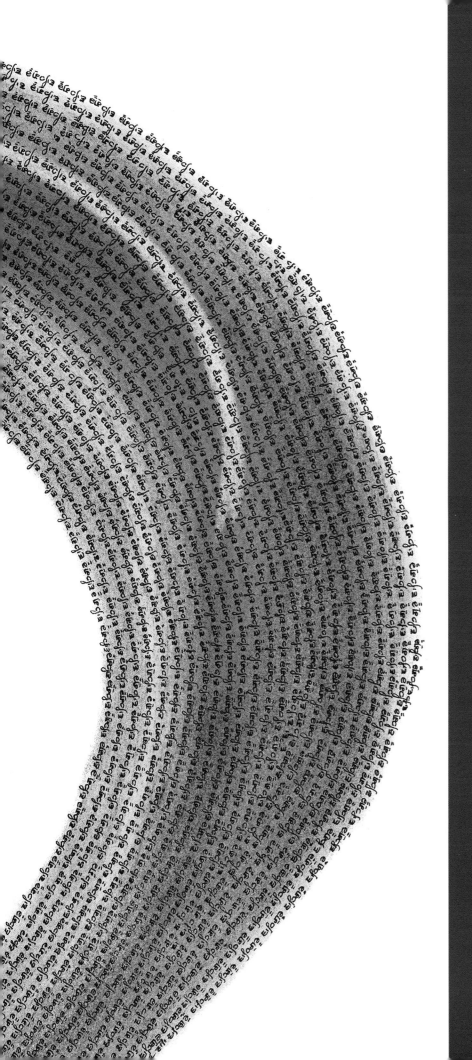

PULLED TOGETHER BY SEPARATION

When love becomes imbued in the colour of the divine, once in a magical while it gets transformed into a divine romance. Being away from a loved one can be excruciatingly painful but, embraced by the universal flow of Oneness, the separation can lead to an intuitive realisation of that Oneness and, thus, the separation becomes a blessing and a joy.

It has taken me decades to just begin to understand this message – something that B used to point out to all of us in many different ways. He told us repeatedly that the greatest thing a person can experience is their unity with the Divine: the most perfect love that we are all seeking. I often marvel at how I never grasped these messages at the time. Although they did bring a deep longing within for this union while I was in B's presence, when the world rushed in I completely forgot the lessons.

Time and personal experiences, like master teachers, helped to reveal further that there is no actual separation from the beloved. Instead, the One's presence can be felt intuitively at all times by tuning into the omnipresence wavelength.

THE BLUE LOTUS

The heart-lotus deep within
has blossomed forth,
and through the Guru,
spiritual wisdom
has been awakened within.

— Guru Arjan

The blue lotus, also known as a blue water lily, has been steeped in symbolism in cultures around the world since the time of the Egyptians.

The elegance a lotus demonstrates when raising itself out of the water each morning, flowering in the radiant sunshine before sinking below the surface later that evening, has been symbolic for the sun, creation, rebirth and resurrection. The blue lotus specifically plays a key role in Buddhism, where its rich colour is associated with the spirit's victory over material attachments, encouraging one to greater self-awareness and a move towards enlightenment.

Each time I see a lotus, its beauty and elegance make my heart skip a beat. The lotus bloom is special for me because of how it is referenced in the Sikh scriptures, its blossoming being compared to self-realisation through the One.

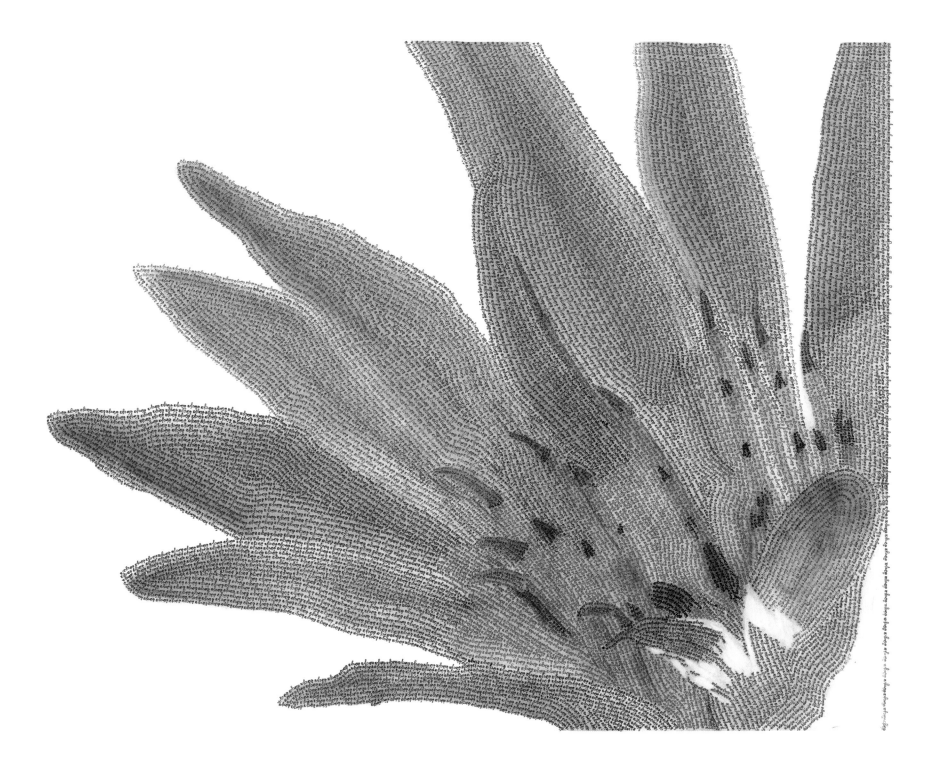

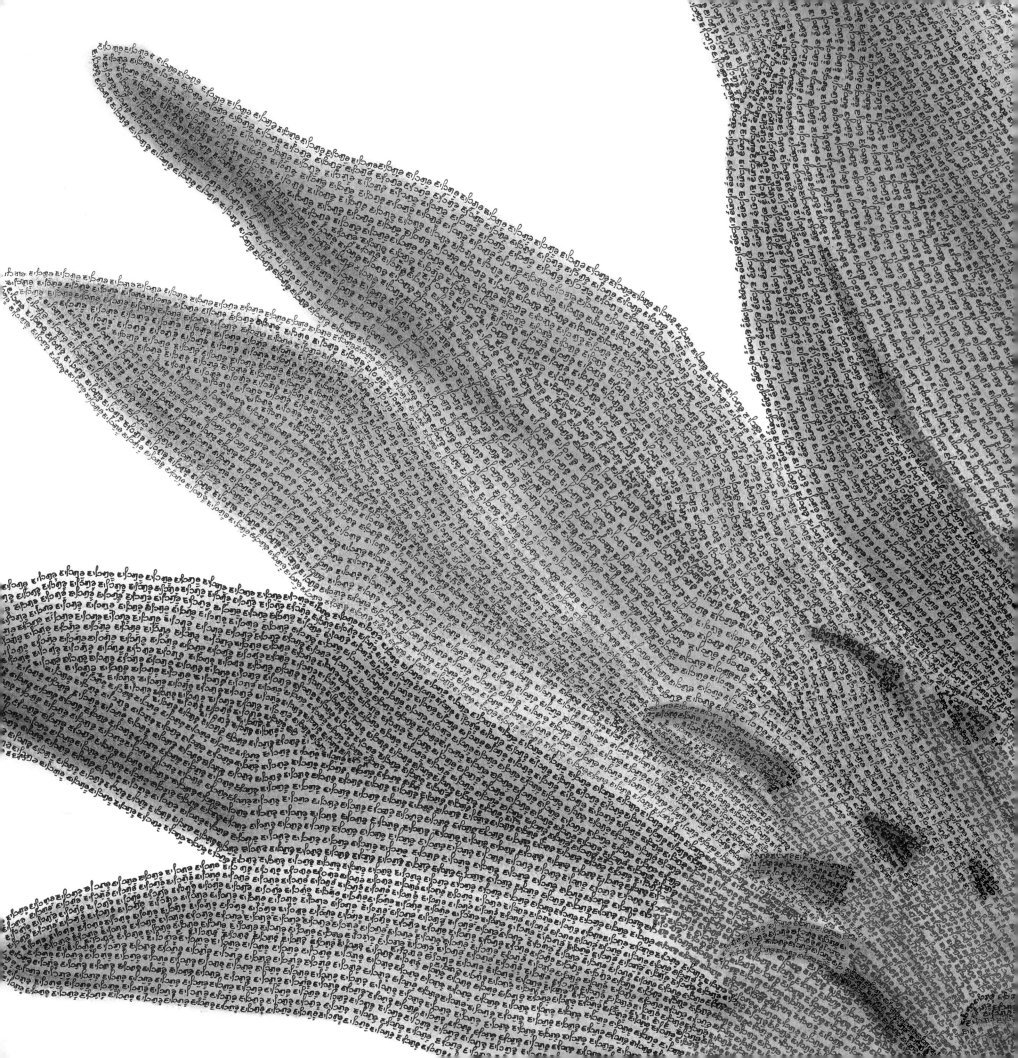

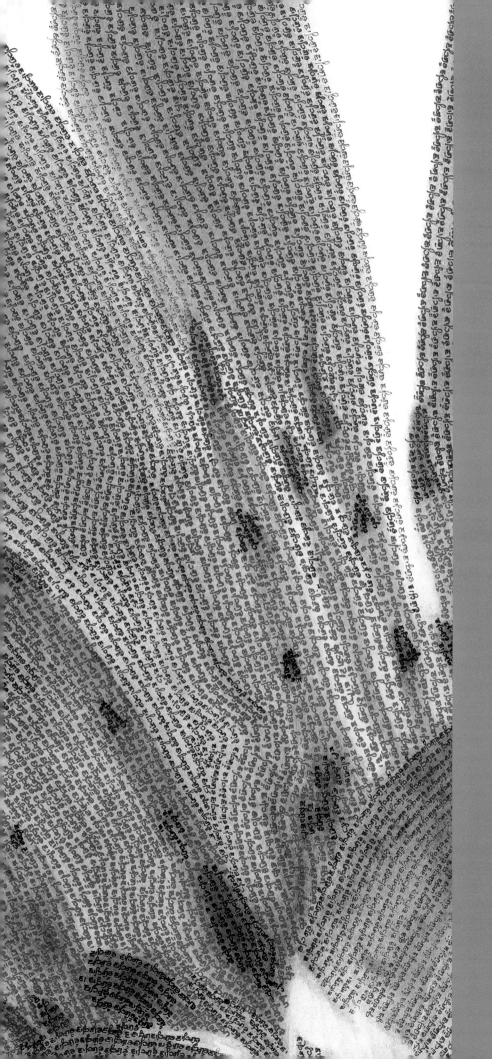

UNAFFECTED BY CHAOS AND CONFUSION

One summer, on a weekend retreat at Lake Saranac in New York, I was kayaking in the early hours of the morning when I came across some exquisite lotus flowers floating near the edge of the lake. I stopped and, in glorious solitude, sat completely still, contemplating these enchanting blooms. They shone, radiating their full glory, completely oblivious to their surroundings as they just simply relished being a part of creation. I could see their strong roots reach deep down through the murkiness of the water.

Could I emulate these flowers in my own life? Could I be rooted so firmly in the awareness of my own divine heritage that nothing else mattered? I had read about the significance of the lotus before but at that precise moment, it had truly seeped deep into my consciousness, urging me to remain detached from all circumstances, whether I considered them good or bad.

Nothing stays the same. Absolutely nothing. And change is inevitable.

The leaves and flowers of the lotus are borne high above the water, almost like an enlightened being, emerging unattached and undefiled from the chaos and confusion of the world. I understood that, like the lotus, we too have the power to rise from the mud, bloom out of the darkness of the materialistic realm and radiate our inner light — the true purpose of this life. Enamoured by their beauty and lifestyle, I was inspired to make two paintings of these incredible flowers.

THE RABAB

*Divine sound is the cause
of all manifestation.
The knower of the mystery of sound
knows the mystery of the whole universe.*

— Hazrat Inayat Khan

Research has shown that music has the power to change emotional states, perceptions and physiology, as well as elevating spiritual awareness. This is certainly true for devotional and sacred music, which can transform individual and collective consciousness into heightened states of love, forgiveness, compassion and physical healing.

Divine music, the song of unceasing sound vibrations, resound incessantly in each and every heart. We can refer to it as the sound current of the Divine Matrix. It is present in every tiny particle of the whole universe. Recognizing this divine link, Guru Nanak, the first Sikh master, encouraged the use of music as a medium to produce spiritual inspiration, a way to produce harmony, and a method to find one's lost inner rhythm. The *rabab*, a lute-like plucked or stringed musical instrument, is closely associated with the Guru's life. When we become totally absorbed in the rhythmic sounds produced by these types of instruments, they can help to transport us to another, ethereal realm. Such music is universal and inhabits all our beings. By tapping into this treasure, even for a split second, we are filled with harmony and peace.

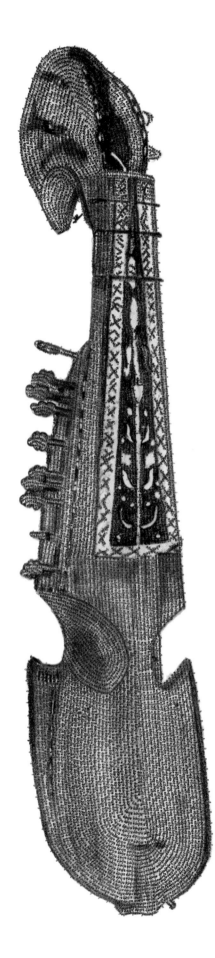

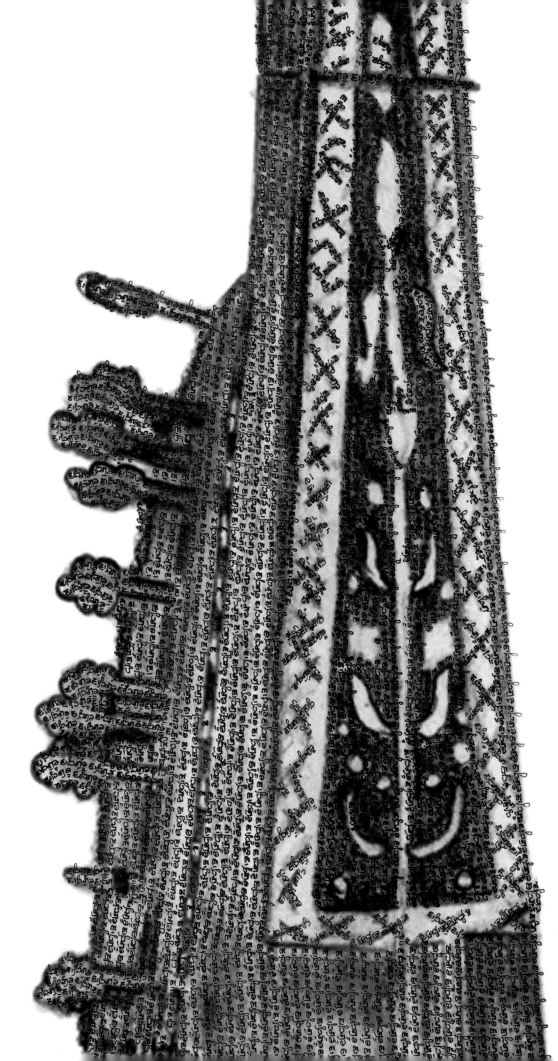

THE PERPETUAL HYMN

The mystic poet Professor Puran Singh is another master that I consider as one of my dearest mentors, someone very close to my heart, and someone who had a direct role in fashioning some of my life choices. Born in India into the Sikh faith, he travelled to Japan around the turn of the 20th century where he became a Buddhist. He returned to the faith of his birth after meeting Bhai Vir Singh, another revered saint-poet, in Punjab. Puran Singh was a biochemist, a lover of nature and beauty, and penned alluring poetry both in English and Punjabi about his own influential masters – something that resonated and fuelled my own love for my beloved mentors.

Puran Singh's words have provided me with spiritual nourishment for over thirty years and so, when I was asked to illustrate a rabab for a recently discovered rare booklet of his, I was absolutely thrilled and felt truly blessed. In *Guru Nanak's Rabab*, which has since been published online, Puran Singh writes: 'Life is a perpetual hymn to the Divine.' For me, the process of creating each painting is that hymn, a longing, a song. As I inscribe the Waheguru mantra in them, I wonder what it would be like to be intoxicated continually by the melody of the master's rabab.

THE RED LOTUS

On the day when the lotus bloomed,
alas, my mind was straying,
and I knew it not.
My basket was empty
and the flower remained unheeded.

– Rabindranath Tagore

Symbolic of human consciousness on the path to spiritual enlightenment, the lotus flower is revered by several of the world religions. It's delicate and beautiful blooms floating in muddy waters signify rising above life's trials and tribulations. It teaches us to let go of things that might be standing in the way of our spiritual growth, even when we are immersed in them. Thus, we should shed our anger, sadness or loss with acceptance, love, forgiveness and compassion.

The red of this lotus flower symbolises that love and compassion within many cultures and I find the Buddhist mantra, *Om Mani Padme Hum*, especially relevant here. Although it has no direct translation, *Om* is the sound of the universe, *mani* is 'jewel', which is indicative of our divine connection to the universe, *padme* is 'lotus flower' and *hum* means wisdom or enlightenment. Thus, the mantra can broadly mean 'jewel of enlightenment in the lotus'.

When we begin to lift our consciousness beyond the difficult circumstances that we all face in life, and touch upon our own divinity and the innate beauty that life has to offer, we can overcome even the most trying of times. Like the lotus, this is akin to finding a new outlook in life, a rebirth brought about by new realisations or a renaissance of beliefs moving beyond good and bad.

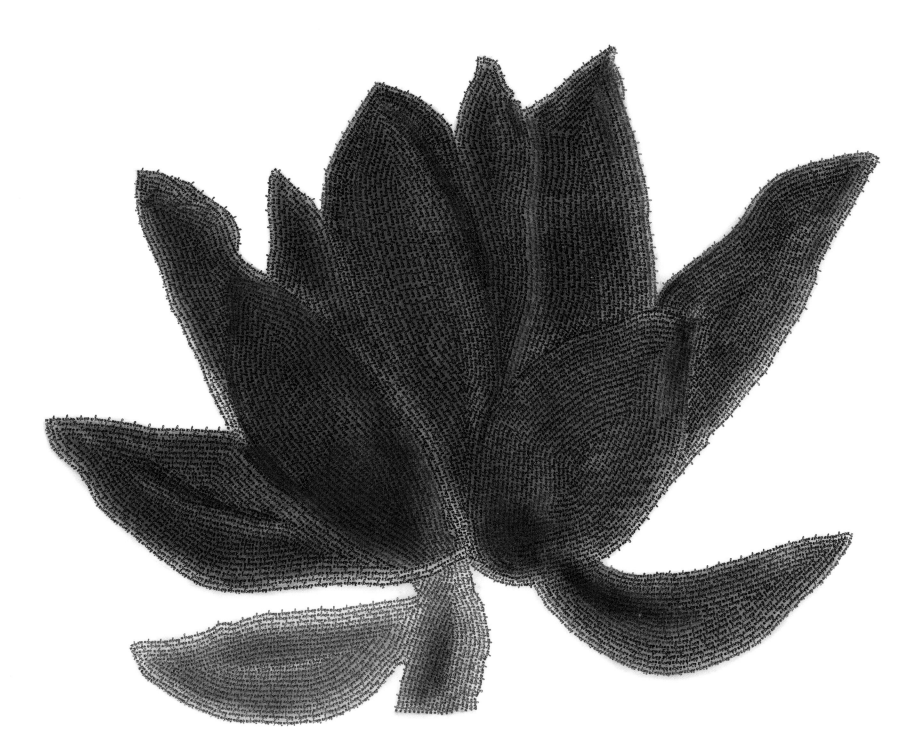

SWEET SCENT WITHIN

I travelled often to various parts of the world to attend spiritual retreats. My mother, wisely and gently, kept reminding me that what I was looking for was within — in other words, I was running around for nothing. However, I was convinced otherwise and was not ready to listen. To help me understand, my mother told me the story of a deer that desperately sought the source of a fragrant musk. Despite searching high and low, the deer could never find it, failing to realise the sweet scent was actually coming from itself. Like the deer, I too was searching everywhere else for direction and acceptance from others when all the guidance I needed was within me – if only I could stop, listen and accept my own self.

Instead, I always remained focused on the exterior rather than the interior. Occasionally, I would feel a glimmer – a 'perfect sweetness had blossomed in the depth of my own heart' as Tagore wrote – that I would long to hold on to. When it slipped away, I could never coerce it back with sheer will alone. Finally, it was only after I stopped charging around, no longer seeking approval and acceptance from the world, that I had the time to be still and in the moment. Since then I have been able to access the feeling more often but not always, and certainly never on demand.

PARMAHANSA

Inspire me to enter
the infinitudes of divine love.
O Universal Spirit,
I would invisibly embrace
as my own all animate
and seemingly inanimate
forms in creation.
May I perceive even in stones,
built of Thy secret atoms,
the pulsing of Thine in suppressible life.

— Parmahansa Yogananda

The graceful, elegant swan symbolises many things. As well as spiritual transcendence, they include love, beauty, purity, stillness and self-discovery. The *parmahansa* or 'supreme swan' state of the soul is a Sanskrit title of honour attributed to one who has acquired spiritual enlightenment. Just as the swan is equally at home on land and water, similarly the enlightened soul is equally at home in the divine and materialistic realms.

The swan's spirit, considered to be of such advanced and beautiful evolution, often sees the bird and spirit become one. It is said that when a swan sings at the time of its death, its spirit is enraptured by a vision of the approaching divine realm. When the swan sings at other times, it brings the sublime sweetness of the divine world back to the material world as it crosses the threshold between the two.

In this painting, the flight of the swan signifies the flight of the enlightened soul – a supreme, master soul that is no longer attached to the illusions of this world but, instead, has merged internally within the Consciousness, with the higher realms.

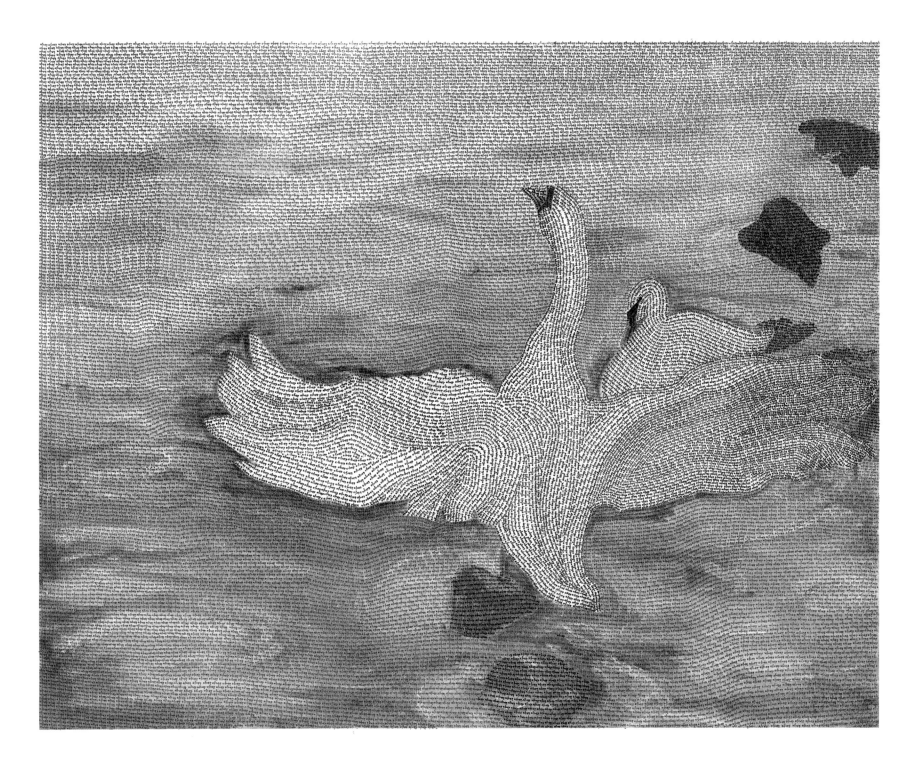

SOARING

I felt distraught during one particularly difficult period. I had reluctantly accepted some responsibilities that were time-consuming and took an emotional toll on me. Feeling overwhelmed, I could no longer concentrate and both my creativity and energy levels suffered. Despite all the lessons I had learnt about detaching oneself, I was fully entangled by every possible string. Even usual antidotes of painting and meditating or my loving network of family and friends did not help.

I felt alone.

Then, I had an epiphany – this feeling of being absolutely alone *was* the lesson that I had to learn.

The void was actually a completeness filled by the omnipresence surrounding and embracing me. Recognising this helped to bring back all previous truths tumbling back into existence for me. My energy soared and a feeling of joyous elation seemed to sprout from within again. I could now examine the illusory appearance of all that had been bothering me without getting invested in it, knowing that all was well and would continue to be fine.

I began to unclutter my life, discarding superfluous responsibilities and letting go feelings of attachment to people, places and things. I now had precious time to be with that completeness I had discovered, to reinforce its presence continuously in my solitude.

Finally, I was able to paint again. This led me to rediscover one of the paintings that I had done over 20 years ago – a swan in flight. At the time, I had no particular reason for painting this scene, but now it spoke volumes. My soul was soaring!

THE FLUTE

*The flute of the infinite
is played without ceasing,
and its sound is love.*

— Bhagat Kabir

More than words, music conveys an experience of the divine by creating a way into the space within, where one is more receptive to the power of the Spirit. Lord Krishna's side-blown, cylindrical flute, *bansuri*, had the power to intoxicate animals and humans alike so much so that they lost consciousness of their bodies. The medieval mystic Meister Eckhart thought the sound of the simple flute could mediate between humans and the divine.

The flute is among the earliest musical instruments discovered by mankind and has been mentioned in many ancient scriptures. Even the Neanderthals built flutes out of bone to express their inner feelings and to imitate nature's sounds. The instrument's wide and slow wavelengths – akin to huge, long breaths – have the power to reach the inner soul of listeners.

Since the melodious, organic, tranquillity-inducing flute is often associated with the gods, we may say that the Flute of the One is actually that great sound current upon which the soul rides in its journey to its true home.

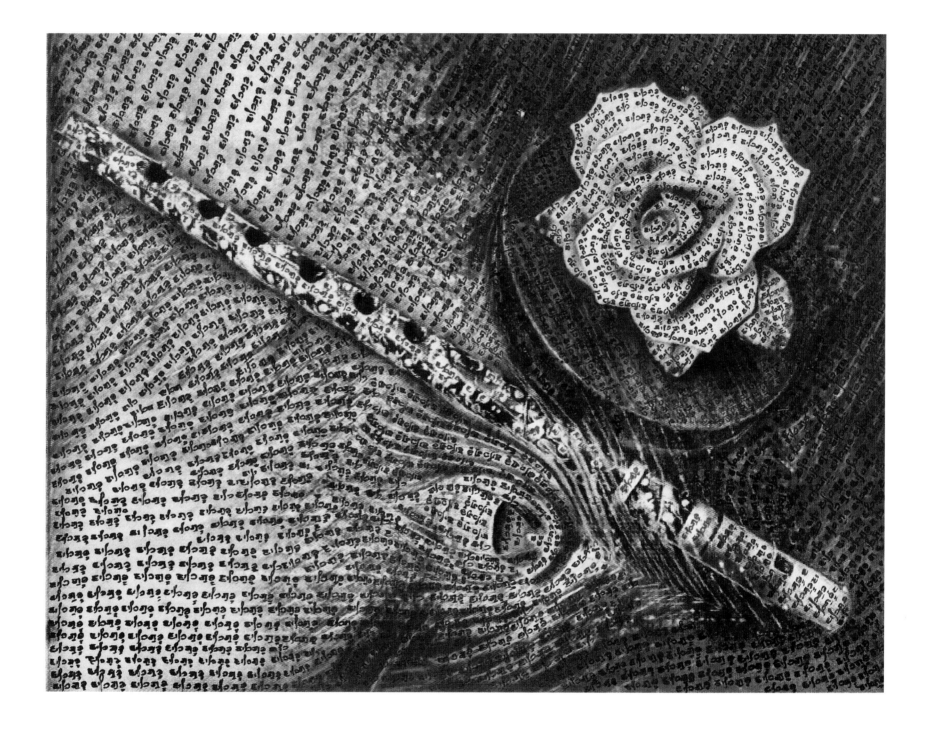

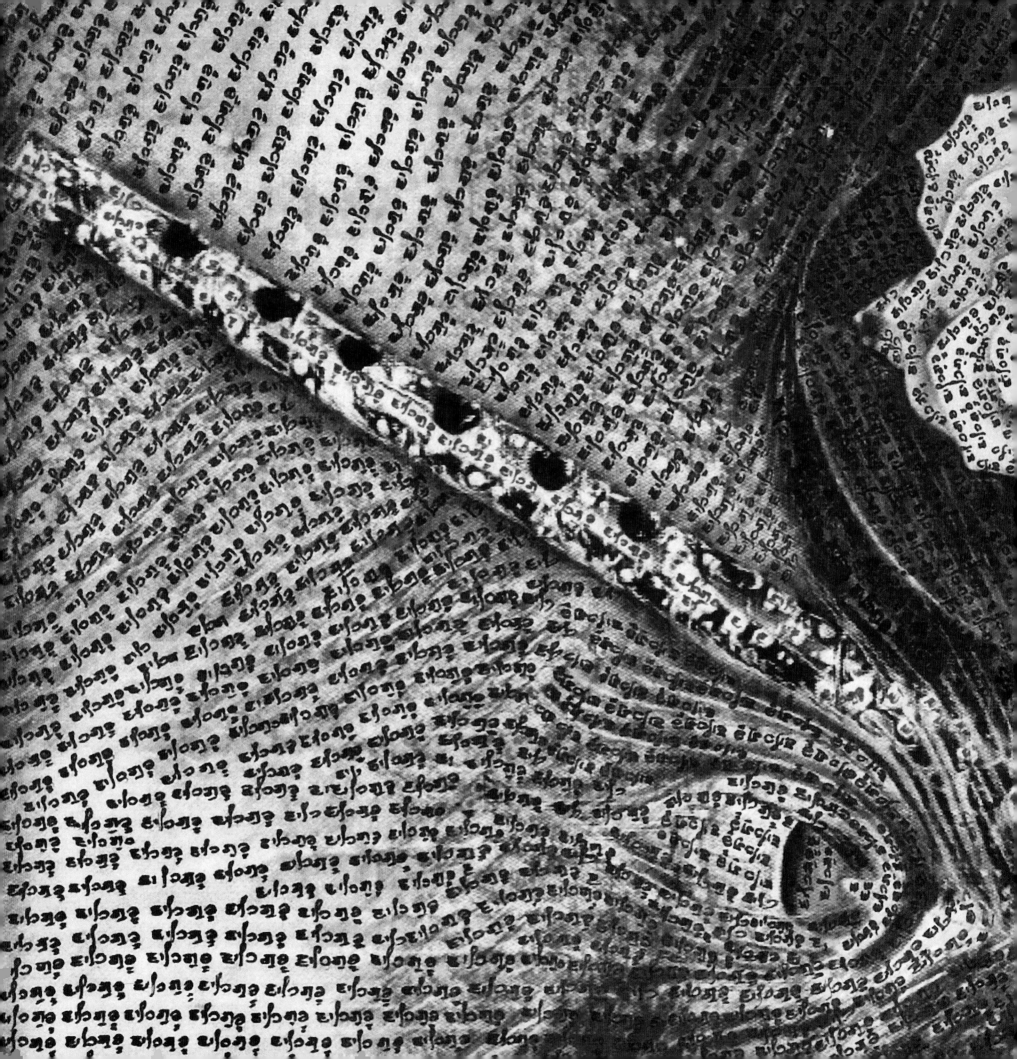

INNER MUSIC

As the consciousness unfolds, practicing omnipresence is a joyous, rapturous experience with the universe revealing more and more secrets. After painting The Rabab, the premise of using external instruments to kindle inner music kept recurring to me. I finally set upon painting a mini-series of tools that can aid us in matching the vibrational frequency of our inner rhythm, thus allowing us to tune in to our internal sounds to bring them into harmony. This series has so far included the *tabla* (a pair of drums), the harmonium and the flute. I am hoping to expand it to include cymbals and the guitar.

I have had the pleasure of playing a harmonium with tabla accompaniment for years. Other than this practice being pleasing to the ears, most of the time I had been preoccupied in the tune rather than being invested in the effect of the sounds on my soul. I knew that the music helped me in some manner but had never considered its vibrational frequency. It was quite an awakening to start paying attention to these more closely. When I did, I was left in awe.

By focusing on the inner rather than the outer, and by forgetting who is playing what and instead getting in tune with the enchanting sounds, I have discovered a form of meditation that has become a powerful on-going practice.

OMNIPRESENCE

The drop is in the ocean,
and the ocean is in the drop.
Who understands, and knows this?

— Guru Nanak

It is believed that Nanak, the first Sikh Master, attained enlightenment in the Kali Bein, a rivulet in Punjab that flows into where the great rivers, the Beas and Satluj, converge. One day, while taking his daily bath, he disappeared and everybody, except his sister Nanaki, thought that he had drowned. She had recognised her brother's divinity and was convinced that no stream or river could drown or carry him away. When the Guru reappeared after three days, Nanaki was vindicated.

According to his own words, Nanak merged with and became Divine Consciousness during that time. By experiencing that he was simultaneously the drop and the ocean at the same time, he realised that the One is omnipresent — there is only *Ek* or 'One' and nothing else.

Once we realise that we are part of the whole, we can start to emerge from the materialistic realm and begin on the journey of recognising that everything, everywhere and everyone is the same Divine Consciousness. The Waheguru mantra used to create this painting is a testimonial to this very omnipresence.

THE CULMINATION

The concept of universal religion has become close to my heart ever since my blessed spiritual guide made me aware of it. Learning the theory is, however, very different from implementing it in one's own life experiences but it was something I longed to know intrinsically.

Over time, as my consciousness began to evolve, I could see it becoming a truth. By now, I had been fortunate enough to travel around the world as an education consultant. Through meeting teachers and students from all backgrounds, who held and practised various beliefs and faiths, I experienced first-hand that we were all the same.

So, when I was invited to visualise Guru Nanak in an abstract form for his 550th birthday celebrations, I was delighted when my search took me to the line from the Sikh scriptures: 'The drop is in the ocean, and the ocean is in the drop.' It brought all my years' works of visualising everything as minute particles, drops of the Divine Presence, to a culmination.

I am utterly and totally grateful for this realisation.

CONCLUSION

ਵਾਹਿਗੁਰੂ

Learnings from my Journey

- Live unapologetically, love fearlessly and hold no animosity, malice or envy for anyone. We are all connected.

- An attitude of gratitude for every situation sows seeds in the present moment, which inevitably produces a glorious harvest in the future.

- We are inherently Consciousness itself, which can only be known intrinsically through grace.

- Daily periods of contemplative solitude are fundamental to realising omnipresence.

- No one in the world can help you except yourself.

- Although we initially need to assert our own individuality and independence, ultimately, we have to turn inward and dissolve all trace of that self.

- True love is extremely rare and a powerful teacher. It completely consumes you, bringing deep understandings before eventually morphing into a love that is grounded in the One, thereby transforming the finite into the infinite.

- Finding stillness within reveals that constructs of the mesmeric mind – like time, space and age – are just illusions.

- Life is magical. Miracles happen all the time.

- The journey never ends.

Row, row, row your boat,
Gently down the stream.
Merrily, merrily, merrily, merrily,
Life is but a dream.

Glossary of Names

The following list of names of people mentioned in the book is ordered alphabetically by first name or title:

Albert Schweitzer (1875–1965): German-French polymath whose expertise included in theology, philosophy and as a physician.

Bhagat Kabir (circa 15th century): Indian mystic poet and saint of the Bhakti movement whose writings are included in Sikh scripture, Guru Granth Sahib.

Bhagat Namdev (1270–1350): Indian mystic poet and saint of the Bhakti movement whose writings are included in Sikh scripture, Guru Granth Sahib.

Bhagat Pipa (circa 1425–early 15th century): Indian king who abdicated the throne to become a mystic poet and saint of the Bhakti movement whose writings are included in Sikh scripture, Guru Granth Sahib.

Bhai Vir Singh (1872–1957): Indian poet, scholar and Sikh theologian who played a pivotal role in the renewal of the Punjabi literary tradition.

Buddha (circa 480–circa 400 BCE): title (meaning 'Awakened One') of Siddhartha Gautama, an Indian monk, philosopher and teacher upon whose teachings Buddhism was founded.

Carl Jung (1875–1961): Swiss psychiatrist and psychoanalyst who founded analytical psychology.

Charles Schulz (1922–2000): American cartoonist and creator of the popular comic strip *Peanuts*.

Chuang Tzu (circa 4th century): Chinese philosopher whose writings formed one of the foundational texts of Taoism.

Emily Dickinson (1830–1886): American poet whose unconventional poems often dealt with themes of death and immortality.

Friedrich Nietzsche (1844–1900): German philosopher, poet and scholar whose work has exerted a profound influence on modern intellectual history.

Guru Arjan (1563–1606): fifth Sikh Guru who built the Harmandir Sahib in Amritsar and compiled the first official edition of the Sikh scripture, Guru Granth Sahib.

Guru Gobind Singh (1666–1708): tenth Sikh Guru who was a spiritual master, warrior, poet and philosopher.

Guru Nanak (1469–1539): founder of the Sikh tradition and first of the ten Sikh Gurus, he travelled extensively across the Indian subcontinent and the Middle East to spread his message of Oneness.

Guru Ram Das (1534–1581): fourth Sikh Guru and founder of the holy city of Amritsar, Punjab.

Hazrat Inayat Khan (1882–1927): classical North Indian musician, teacher of Universal Sufism and the founder of the Sufi Order in the West.

Henri Matisse (1869–1954): French artist known for his intense and expressive use of colours.

Henry David Thoreau (1817–1862): American essayist, poet, and philosopher best known for his book *Walden*.

Jesus (0–circa 33): preacher, religious leader and the central figure of the Christian faith.

Joel Goldsmith (1892–1964): American spiritual author and teacher who founded The Infinite Way movement.

Khalil Gibran (1883–1931): Lebanese-American writer, poet and visual artist best known as the author of *The Prophet*.

Khoji (1903–1999): pen name (meaning 'The Seeker') of the author's spiritual mentor.

Krishna: major Hindu deity and the eighth avatar of the god Vishnu.

Lao Tzu: ancient Chinese philosopher, writer and founder of philosophical Taoism.

Leonardo da Vinci (1452–1519): Italian Renaissance polymath whose areas of expertise included painting, drawing, science, mathematics and engineering.

Leo Tolstoy (1828–1910): Russian writer best known for his novels *War and Peace* and *Anna Karenina*.

Lynda Nelson: author of inspirational children's books.

Martin Luther (1483–1546): German priest and professor of theology who played a pivotal role in the Protestant Reformation.

Max Ehrmann (1872–1945): American writer and poet best known for his poem *Desiderata*.

Meister Eckhart (circa 1260–circa 1328): German theologian, philosopher and mystic.

Nelson Mandela (1918–2013): South African anti-apartheid revolutionary, political leader and the first black President of South Africa.

Nikola Tesla (1856–1943): Serbian-American inventor and engineer best known for his contributions to the design of modern electricity supply systems.

Parmahansa Yogananda (1893–1952): Indian monk, yogi and guru who introduced meditation and Kriya Yoga to westerners.

Phil Cousineau (1952–): American author, writer and filmmaker.

Plato (circa 424–circa 348 BCE): Athenian philosopher during the Classical period in Ancient Greece.

Professor Puran Singh (1881–1931): Punjabi poet, scientist and mystic considered one of the founders of modern Punjabi poetry.

Pythagoras (circa 570–circa 495 BCE): Ancient Greek philosopher, mathematician and scientist.

Rabindranath Tagore (1861–1941): Indian polymath who became the first non-European to win the Nobel Prize in Literature.

Ralph Waldo Emerson (1803–1882): American lecturer, philosopher and poet who led the transcendentalist movement of the mid-19th century.

Robert Browning (1812–1889): English poet and playwright.

Rumi (1207–1273): popular name of Jalal ad-Din Muhammad Rumi, a Persian poet, Islamic scholar and Sufi mystic.

Saint Francis of Assisi (circa 1181–1226): Italian Catholic friar, deacon and preacher who is one of the most esteemed religious figures in history.

Saint Theresa of Avila (1515–1582): Spanish noblewoman who led a monastic life in the Catholic Church as a nun, religious reformer and author.

Saryu: Japanese Zen poet.

Søren Kierkegaard (1813–1855): Danish theologian, poet and social critic who is widely considered to be the first existentialist philosopher.

Thomas Merton (1915–1968): American Trappist monk, writer, poet and scholar of comparative religion.

Ute people: Native Americans who were the original inhabitants of the regions of present-day Utah and Colorado.

Walt Whitman (1819–1892): influential American poet, essayist and journalist.

Yunus Emre (1238–1320): Turkish poet and Sufi mystic.

Acknowledgements

I would like to express my heartfelt thanks to a number of people for their magnificent support and contributions to my journey and to the creation of this book.

Foremost, I would like to offer my deepest gratitude to my revered spiritual mentors and all the esteemed master teachers from the past whose writings lit a flame inspiring me to follow them in their footsteps. Thank you from the core of my being to each and every person that came into my life, who left their loving mark on my heart, illuminating me through their presence and leaving me changed forever. The generous sharing of your love and wisdom, light and divinity, continue to shine through my life and I cannot ever repay you for the largesse of your spirit. Walking in the shadows of your greatness, I honour every one of you.

This book would not have been possible without the loving and unflinching support of all my immediate and extended family and friends. Thank you a millionfold for believing in me, pushing me, giving me the necessary and timely scaffolding, and keeping me motivated throughout the process. I am very grateful for all your love, patience, advice and encouragement and feel blessed to have each and every one of you precious gems in my life.

I would also like to extend my ardent gratitude to Parmjit Singh, Dr Bikram Singh Brar, Parambir Grewal and Sukhdeep Singh at Kashi House. You are responsible for weaving my glorious journey brilliantly by editing and transforming my words, and presenting the related artworks in the best manner possible. Thank you from the bottom of my heart for believing in me and making my dream a possibility. I am deeply grateful to Tia Džamonja for designing such a beautiful book. I am also indebted to Andriy Drobotov (MP Repro) and his team for their advice and guidance. Amrit Mann and Harkirat Assi, the team behind Punjab Arts, graciously stepped up to offer their support for the project.

Profound thanks to Jasreet Kaur for helping me in a thousand ways. Whether it was with the social media, editing, keeping me focused or getting the files ready she was always there. I appreciate your generosity and loving support. My dearest friend who told me to 'look up', thank you for your invaluable advice! To all those others who are too numerous to name but have helped me illuminate every breath and continue to do so on this glorious journey – a thousand-fold thanks.

Finally, on behalf of my publisher, I would like to thank Dr Amritpal S Pannu & Mrs Amritsagar Pannu, K. S. Chana (Chana Chemist Group), Kabaljit Singh Sandhu (DBK Estate Agents) and Santokh Singh Chhokar (Chhokar & Co Solicitors) for their invaluable financial support in helping to get this book out into the world.

About the Author

DR JUSS KAUR has been a teacher and international education consultant for over four decades and is currently an Adjunct Professor of Education at McGill University.

In a recent TEDx talk, Juss Kaur spoke on the profound concept of Oneness that she conveys through her meditative artworks, which have been exhibited at:

2018 Parliament of World's Religions (Ontario) l Peel Art Gallery, Museum and Archives (Ontario) l 3rd Global Conference on World's Religions (Québec) l Art galleries in Montreal, Ottawa, Toronto and Vancouver l Naam Ras 2018, Singapore Expo

To learn more about Juss Kaur and her unique art form visit:

JussKaur.com

Instagram: @JussKaur_Art l Facebook: JussKaurArt l Twitter: @JussKaur

Inspired by the Sikh concept of seva, Juss Kaur will be donating 100% of her profits from book sales to Khalsa Aid International (registered charity no 1163294), a UK-based humanitarian relief charity providing support around the world to victims of natural and man-made disasters such as floods, earthquakes, famine and war.

For further details please see www.KhalsaAid.org.

About the Publisher

KASHI HOUSE CIC is the only mainstream publisher in the world dedicated to producing high quality books on the rich cultural heritage of the Sikhs and the historic region of Punjab that today spans northern India and Pakistan.

The company was established as a not-for-profit social enterprise in 2006. All profits are reinvested in new projects.

For further details of our books, authors, art prints & events please visit:

kashihouse.com

Instagram: @kashihousecic l Facebook: kashihouse l Twitter: @kashihouse